the CIRCLE

LUCA LOCATELLI

SOLUTIONS FOR
A POSSIBLE FUTURE

edited by Elisa Medde

Gallerie d'Italia | Skira

*Our thanks go to the companies
photographed during the project*
Algalif, Iceland
Aquafil, Iceland
BEF Biosystems, Italy
Blue Lagoon, Iceland
Carbfix, Iceland
Comistra, Distretto tessile di Prato, Italy
Ecoduna, Austria
Enel Green Power, Italy
Favini, Italy
Ferropolis / MELT Festival, Germany
Haustak, Iceland
Lefdal Mine Datacenter, Norway
Mejillón de Galicia, Spain
Nemo's Garden, Italy
Romande Energie, Switzerland
Salina Turda, Romania
Soex, Germany
Stolt Sea Farm, Iceland
Tarmac Aerosave, France
Università di Torino / Dipartimento di
Scienze della Vita e Biologia dei Sistemi, Italy
Vaxa, Iceland
Wunderland Kalkar, Germany

Special thanks to the Favini paper mill

Gallerie d'Italia | Skira

Gallerie d'Italia
is the Intesa Sanpaolo Project
on art and culture

Skira editore S.p.A.

Massimo Vitta Zelman
Chairman

INTESA SANPAOLO

Giovanni Bazoli
Chairman Emeritus

Gian Maria Gros-Pietro
Chairman

Carlo Messina
*Managing Director
and CEO*

Paolo M. Grandi
Chief Governance Officer

Michele Coppola
Art, Culture and Historical
Heritage
Executive Director
Gallerie d'Italia
Director

Just over a year ago, Intesa Sanpaolo established the Gallerie d'Italia in Turin, dedicating the bank's fourth museum to photography and launching a programme of commissions to explore the major issues of contemporary life.

There is no question that images have a tremendous impact on today's society; indeed, "a single photo can possess a power previously unimaginable" to quote Luca Locatelli, the iconic Italian photographer to whom the new exhibition at Palazzo Turinetti is devoted. The Gallerie d'Italia gives space to photography not only for its artistic value, but precisely because it is a powerful and effective means of spreading topical and profound content, involving the wider public, and questioning us all about the challenges to be faced in the present and future.

The exhibition the CIRCLE addresses some of the most pressing issues of our time, such as the circular economy and ecological transition, through compelling images by Luca Locatelli, whose research is aimed at documenting solutions that will help the planet and humanity to survive. In recent years, his work has won international prizes, including the World Press Photo Award in the Environment category, the Leica Oskar Barnack Award and the World Photography Organisation Award. Between 2021 and 2023, under commission from Gallerie d'Italia, Locatelli undertook a journey across Europe, on which he translated into extraordinary images some of its most successful circular economy projects. Their merit is to have pursued a sustainable economic model which, through technological support and innovation, manages to combine production activity with respect for the environment, natural resources and social progress, in a harmonious, balanced way. The artist conducted his research in places as far apart as Italy, Iceland, Norway, Romania, Germany, Switzerland and Galicia, where it encompassed the floating photovoltaics on the Lac des Toules, textile recycling in Prato, and the coal mine in Saxony-Anhalt that has been transformed into a cultural centre.

The result is a documentary photography project of international reach, realised with the invaluable contribution of the curator Elisa Medde and the support of prestigious partners, with whom our bank shares social and cultural values and aims. In fact, the show has benefited from the knowledge support of the Ellen MacArthur Foundation, one of the first and most important global organizations dedicated to the circular economy and sustainability, as well as a contribution from Fondazione Compagnia di San Paolo and Fondazione Cariplo, two institutions that have always played a key and historic role in development processes in the territories where they operate. The project assigned to Luca Locatelli significantly expresses the broad vision of Intesa Sanpaolo, which considers the circular economy a strategic part of its social responsibility, as attested by the bank's Business Plan. Our Group's social commitment is expressed through various actions, such as its alliance with main partners in the sector – first and foremost the above-mentioned Ellen MacArthur Foundation –, the creation of the Circular Economy Lab, its support to companies that apply the principles of circularity, as well as consulting, research and training activities. The exhibition the CIRCLE at Gallerie d'Italia reinforces this commitment, drawing on the capacity of art to involve the public, in order to make us all aware that through our own behaviour we can bring about a change that can no longer be postponed. The message is aimed particularly at youth, because the beauty of these images speaks of great dreams that have come true. Our hope is that Locatelli's work will trigger emotions and reflections that will help to effect the cultural transformation necessary for the birth of new and more sustainable development models.

Giovanni Bazoli
Chairman Emeritus
Intesa Sanpaolo

Design – it's all around us. Our homes are designed. As are offices and cars. But also the infrastructure systems we use to get from our homes to our offices. Our cities and the services that work within them are all designed. Design defines what we choose to wear and for how long. It even shapes the food we eat, how it's produced and where it's displayed in supermarkets. Currently, the vast majority of our designs are linear. We take materials from the earth, use them to make things, and then – usually after a very short time – we throw them away. Our systems operate in silos, so we waste time and resources. And our economy is built on extraction and exploitation.

The circular economy, by contrast, offers a different pathway. It harnesses design to reimagine and recreate the systems, services and goods that flow through our economy to circulate products and materials, eliminate waste and regenerate nature. In this way, it can help us tackle the interconnected global crises of climate change, biodiversity loss and pollution.

Currently, 45% of global greenhouse gas emissions come from how we make and use things. The extraction and processing of natural resources account for 90% of biodiversity loss. And while transitioning to renewable energy is essential, it is not going to be enough. To avoid simply patching up our flawed linear system, we must design something different. We must transition to a circular economy. This challenge is monumental but fundamental and it requires collaboration, vision and transparency.

At the Ellen MacArthur Foundation, our mission is to help accelerate this transition. We produce research, resources and tools to explore, develop and support solutions that can help us realise a circular transformation. We've brought together thousands of key players from business, government, charities and academia to create the world's leading circular economy network. And we've created the Circular Design Leaders, a group of design pioneers working with organisational leadership to implement circular design, empower design and innovation teams through knowledge sharing, and communicate circular design progress to the wider design audience.

Intesa Sanpaolo is a Strategic Partner within the Ellen MacArthur Foundation's Network and we are thrilled to be providing knowledge support to Luca Locatelli's exhibition at the Gallerie d'Italia in Turin. There are many groundbreaking solutions already in place that have the potential to scale and accelerate the transition to a circular economy – some of which are included in the CIRCLE. They show us what is possible. Now is the time to bring these circular, regenerative futures to life.

Joe Iles
Circular Design Programme Lead
Ellen MacArthur Foundation

The concept of economy, understood as the orderly and rational management of our "home", could not be more appropriate for our times. The public has now realised that the environment so extensively occupied by humanity, which has organised itself in so many different ways, is our only home and a finite reality like everything else in the world. This awareness is particularly keen in the younger generation, as well as in the majority of the scientific community and, to a lesser extent, the political world.

At least three factors have contributed to this realisation and to the efforts to implement adequate policies, with results that are already visible but far from sufficient.

The first is the obvious changes in our climate, whether these stem solely from human activity or also depend on alterations in natural systems, which can be deemed of secondary importance. We need to reduce the known causes and build adaptation systems on every scale.

The second factor is the finite nature of resources: a concept of development – assuming that there has been one, since Malthus, in modern times – that sees the planet as a bottomless well from which we can draw materials to be transformed, consumed and dispersed without a thought for the environment, simply no longer holds water.

The third is the realisation that although our economic systems are the most advanced since the dawn of humanity and capable of sustaining an unimaginable affirmation of the species, they are incapable of producing sufficient levels of well-being to guarantee a decent life for all human beings (where "decent" increasingly implies common benefits in the distinctly heterogeneous contexts of the planet: access to basic goods, sustainability, equal rights and equity). This shows us that our systems of production and consumption, as well as of resource provision, need to be fundamentally rethought.

I believe that, once again, we have to avoid falling into the trap of being "apocalyptic" or "integrated". The former proves sterile, while the latter is passive and, let's be honest, immorally convenient. The point is where to start in order to be exactly the opposite, that is "constructive" and "critical". And the two attitudes must co-exist.

The discourse emerging at this point is so complex – which does not mean the subject cannot be addressed – that there is no room to pursue it here. We do, however, have a very important guideline, of which we must never lose sight: the United Nations 2030 Agenda for Sustainable Development and its 17 Sustainable Development Goals. While some people look on this agenda somewhat patronisingly, and we know full well that the majority of the goals will unfortunately not be achieved in the next seven years, there are two fundamental aspects of which we should never lose sight – aspects that a policy-making body like the Fondazione Compagnia di San Paolo keeps in mind when working out choices and strategies. The first is the systemic approach to social, cultural, economic, environmental and political issues,

and the second, the assumption that the responsibility for "sustainability", in the richest sense of the word, does not only lie with governments, economic-productive systems or science. Indeed, it is an inherently common responsibility, involving the behaviour of all "human realities", from individuals to families, communities, and the functionally specialised structures in which complex societies such as ours are organised. It is also crucial to continue building relationships and partnerships between entities at various levels and with different missions, within a framework of "trust", "inclusion" and "informed consent": values that underpin creative collaboration on the fundamental choices of our associated living.

This approach can be applied to the circular economy. The negative external sides of production and consumption are clearly visible today, but the technological and organisational means also exist to reset all our processes, including individual habits, in order to reduce waste, engineer production-consumption cycles that do not cause uncontrolled dispersion of waste into the environment, and ensure the recovery of used materials – we are only at the dawn of the application of generative artificial intelligence in this field. I would also add that some reconversion to less physical forms of consumption would be an interesting step forward, especially in societies that we still call affluent.

Culture plays a very important role in these transformation processes; indeed, it actually becomes an agent of change. A different dimension of our relationship with the "material" has to be explored culturally, using the diverse approaches that art and communication have at their disposal – from provocation to celebration. Change is based on changing mentalities, and culture mirrors this. The Fondazione Compagnia di San Paolo has supported Intesa Sanpaolo in defining the strategies of Gallerie d'Italia - Torino since its inception. The museum is conceived as a cultural bastion open to the entire city, capable of exploring the complex challenges of the future linked to environmental, social and economic sustainability. Hence, after collaborating on JR's Déplacé·e·s, we are delighted that Luca Locatelli's exhibition the CIRCLE has given the Gallerie d'Italia and the Compagnia another chance to jointly contribute to providing information and stimulating concrete actions. Our aim is to engage the public, citizens and tourists who will visit the exhibition, and raise awareness on the issues of today, especially the one central to our existence: environmental sustainability.

Francesco Profumo
Chair
Fondazione Compagnia di San Paolo

I have been asked on several occasions for a simple definition, the most immediate meaning we can grasp, of a word that we hear used a lot these days – and, I would add, fortunately: sustainability. There are many ways to define this term, but the one I think is the most appropriate and the one I like best is this: for me, sustainability means that in five, ten, fifteen years' time (in short, within a timeframe in which we may meet here once again) we will be in a place, in a context, in a world that is better and not worse than the one we have now.

It means taking care of those who will come after us, not using the resources available to us today and leaving the crumbs or the problems to those who will come in the future.

An economic system, a society, is sustainable only if it improves in harmony and also allows those who come after to live in a pleasant community, as has happened to our generations.

It is essential that the concept of circular economy becomes an integral part of our daily actions. Of course, it is very important that the impulse comes from the government, that it be adopted as a practice by companies, but also that it enter our homes as an everyday attitude. Because it is good not to waste, it is useful and it benefits everyone.

In recent months, I have had the honour and great responsibility of leading an important institution that is very committed to the circular economy and to economic, social and environmental sustainability in general.

In the first phase of analysing the strategy that will guide Fondazione Cariplo's actions from 2023 to 2026, we looked at the trends of what is happening in the world, because although our Foundation operates at a local level, it is obliged to keep an eye on megatrends and planetary phenomena. As a method (and a passion), I have always tried to base a line of reasoning on data, for there is an infinite amount of information available today that – if interpreted and used correctly – offers fundamental keys to interpreting actions, particularly with a view to the future.

For example, there is one piece of data that allows us to understand what we are facing and that is the world's per capita energy consumption: Americans consume more than four times the world's average per capita energy consumption, while each Indian consumes less than a third of the world's average. There are populations and countries that are high energy consumers, and others that are far from it. In general, those who live in the regions that consume less belong to very large populations; this means that if these people wished to attain (or were to attain) Western standards, the world would have no chance of providing these resources to everyone, except at great risk of collapse.

Here is one reason, a concrete example, why we all need to adopt a sustainability mindset.

The key point is this: we need to act simultaneously on two fronts, creating opportunities for development and reducing fragility and inequality. Never before have these two goals been so closely linked. And we need to take a planetary view.

In this broad and complex context, I see Fondazione Cariplo as an enzyme that triggers reactions. It does this at a local level, in the area where it mainly operates: Lombardy and the provinces of Novara and Verbano Cusio Ossola; but we are well aware that today, precisely because we live in an interconnected world, practices that work can be applied elsewhere and bring benefits, according to the principle of scalability.

The Milanese Food Policy System, which bases its activities on recovering and fighting against waste, was considered such a virtuous example that in 2021 it won the first edition of the prestigious international Earthshot Prize in the "world without waste" section – intended for the best solutions to protect the environment – after being evaluated by an international committee of experts that selected Milan from 750 initiatives from all over the world.

The prize – worth £1 million – will be used to strengthen the neighbourhood centres that recover and distribute food.

The aim is to open new collection and distribution centres ensuring their long-term sustainability and replicate this good practice in the network of cities working with Milan on food policy starting with the network of cities that have joined the Milan Urban Food Policy Pact.

Winning the Earthshot Prize is recognition of a great team effort involving the whole city: thanks to the municipality and the many businesses in the service sector, university, large retail and philanthropic organisations active in the area.

Born in 2017 from an alliance between the Municipality of Milan, Politecnico di Milano, Assolombarda, Fondazione Cariplo and the QuBì programme, the project has since involved the Banco alimentare della Lombardia and has enabled it to save – with the first hub alone – more than 10 tonnes of food per month and ensuring in one year a flow of 260,000 equivalent meals that reached 3,800 people, thanks to the contribution of 20 supermarkets, 4 company canteens and 24 service sector entities.

I have used this example because it materially represents an action based on sustainability and the circular economy.

A further testament to this is the fertile collaboration with Intesa Sanpaolo and Gallerie d'Italia in the realisation of Luca Locatelli's exhibition project the CIRCLE, which sees the bank and the foundation united in their commitment to promote and spread the culture of sustainable development.

To be successful, it is necessary to work together – institutions, companies, service sector – in local communities, with a focus on the most fragile and an eye towards the rest of the world and the future of the forthcoming generations.

Giovanni Azzone
President
Fondazione Cariplo

Cover
Biosphere Underwater
Farming #3, Italy, 2021

Art Director
Luigi Fiore

Design
Anna Cattaneo

Editorial Coordination
Eva Vanzella

Copy Editor
Carlotta Santuccio

Layout
Evelina Laviano

Translations
Lucian Comoy for Scriptum,
Rome (pp. 7, 10, 11, 20, 32, 44, 52,
76, 82, 92, 98, 100, 108, 110, 116,
118, 120, 122, 132, 138, 140, 144)
Gordon Fisher, Traduzioni Liquide
(pp. 14–19)

Papers
Favini, Alga Carta White 160 g,
Crush Citrus 120 g,
Crush Olive 120 and 250 g

FSC
www.fsc.org
MIX
Paper from
responsible sources
FSC® C018150

First published in Italy in 2023 by
Skira editore S.p.A.
Palazzo Casati Stampa
via Torino 61
20123 Milano
Italy
www.skira.net

© 2023 Luca Locatelli
© 2023 Intesa Sanpaolo
© 2023 Skira editore, Milan

Printed and bound in Italy.
First edition

ISBN: 978-88-572-5138-7

Distributed in USA, Canada,
Central & South America
by ARTBOOK | D.A.P., 75 Broad
Street, Suite 630, New York,
NY 10004, USA.
Distributed elsewhere in the
world by Thames and Hudson
Ltd., 181A High Holborn, London
WC1V 7QX, United Kingdom.

CONTENTS

THE CIRCLE ELISA MEDDE

The circle is the elementary shape that it is easiest to see in nature. Just think of the sun or the moon, or drops of rain. A symbol of power and equidistance, harmony and completeness, the circle is also a representation of the divine, of itself and of infinity. If you close the circle you do your duty, you resolve the mystery. It is a magic symbol, capable of evoking energies and amplifying frequencies, it is a spiritual symbol, an image of resolution and of the great equilibrium of everything. Moreover, it is also how we depict our planet, in its three-dimensional form as a sphere. In truth it is an ellipsoid, but we will come back to that later.

In our time, in the era of total relativisation, the circle is also the important representation of a philosophical paradigm: circularity. The natural distillation of the set of ideas and characteristics associated with the figure of the circle, circularity connotes an approach aligned with the immutable laws of nature, balanced and equidistant, resolved. Indeed, an existence that closes the circle is a complete, accomplished one. Circularity is also a paradigm that has found one of its most significant contemporary expressions in economic theory, where it is considered as the opposite of *linearity*. Some time around the 1960s,[1] the Western world began to ask itself the following question: could the method of production based on the accumulation of capital deriving from the extraction of raw materials – to be transformed into other things destined to be abandoned within a variable but unavoidable timeframe – actually be *sustainable*? In a major conceptual overhaul, terms such as "recirculation," "reuse" and "recycle" began to appear with increasing frequency in valuations and analyses of long-term prospects and wealth potential, eventually identifying the key points of the problem: how to manage the end of primary resources? Is exponential growth truly endless? How should we deal with all the waste?

With the passing of time, we have realised just how much these concepts were not pure theoretical speculations emerging from economic and political macrosystems. In fact, they were, and are, real issues, made all the more urgent by our awareness of not only having squandered the natural resources and strewn the planet with waste for the benefit of a minimal percentage of the global population, but also of having gravely corroded the climatic equilibriums that make our planet habitable. The circular economy movement was consciously developed in tangible fashion in the 1990s, with the intention of tackling the problems caused by the linear development of human economic, productive and social activities and coming up with possible solutions for the short and long terms.

This is an ambitious movement, full to the brim with contradictions and brilliant insights. A new utopia in which, this time, it is the practice providing the presuppositions for the theory, rather than vice versa. Containing within it a

plethora of radically different minds, from the fields of science, economics, farming, food production, physics, philosophy, engineering, human rights, meteorology and education, amongst others, the circular economy as a whole forms one enormous collective brain, transnational and multifaceted, which creates new neural connections through the practical experiences that it shares. They are conscious actors in an epoch-making transition that posits and promotes a long-term vision in place of immediate success, sharing and recirculation rather than accumulation, and a raising of awareness of our responsibility towards future generations. It has been a fascinating, tortuous and complex journey, which has also made it possible to shine a spotlight on the great contradictions and biases that have led humanity to this difficult moment in its history. We can no longer ignore the role that, historically, empires and colonial systems have had and continue to have in plundering and wasting natural resources. The consequences of this approach – not just on natural but also (and indeed, above all) on human equilibriums – are now so terribly clear and present. Alongside these elements, there is also the profound responsibility of economic systems geared towards accumulation, as well as the trickle-down theory of wealth distribution, the wholesale exclusion of the global south from the decision-making and management mechanisms concerned with the planet's resources, and the religion of consumerism. After all, our planet remains an ellipsoid, and so there is no guarantee that a perfect equilibrium can be reached in any case.

And yet, despite all of the contradictions, contrary forces, denialism and failures, this great experiment in transition is progressing and making quantum leaps, with stories that are apparently disconnected, unaware of each other and perhaps even in competition, but in reality are all part of the synchronic effort to close the circle and to conduct research at the highest level of approximation with a view to achieving that equilibrium, that sustainability between resources and consumption which would ensure a possible future for us on this planet.

Luca Locatelli has spent many years documenting and researching the roads of the great collective journey created by the experiences of this new utopia that we call the circular economy. In his decade-long commitment, which is condensed in the stories commissioned for this exhibition, he succeeds in taking an initial, crucially important step: showing what it is all about, displaying what we are talking about when we make reference to the circular economy. Communicating the practices associated with the circular economy, making them part of everyday speech, accessible to the largest-scale systems and to the personal and household economies alike, has always been complex and only partially effective: today we all know, for example, that there is too much plastic and that disposing of it is problematic,

but only reluctantly are we prepared to go beyond the immense smokescreen of waste sorting. What happens afterwards? And beforehand, in the manufacture of plastic?

The selection of practices and stories that compose this project affords a surprising opportunity: to get up-close and personal with the revolution that is already taking place, and to become part of it in some way.
The CIRCLE is a documentary photography project that describes the revolution of possible solutions. As the outcome of a very far-reaching research project, Locatelli has documented the best practices, experiments, ambitions and pathways of this new utopia. The exhibition route takes us on a trip across Europe – as the embodiment of experimentation and sustainable industrial progress – addressing themes such as geothermy, the recycling of textiles, the regeneration of former industrial areas and food production.

These issues are not new for Locatelli, who has devoted time and energy to them continuously over the past ten years, in the form of numerous editorial and photo assignments published in the leading international magazines.
For *the CIRCLE*, though, an unprecedented, fortuitous and far-sighted synergy of forces was put in place: the project arose out of a commission from Intesa Sanpaolo/Gallerie d'Italia, which provided Locatelli with the funding and support to engage with a new narrative approach in terms of visual storytelling. The initial question was very simple: what are today the best practices that unite industrial manufacturing and the circular economy in Europe, those that could represent a blueprint for the potential of the future? And to what extent can the strategies of documentary photography be put to use by this form of storytelling to create a narrative that is at once informative and fascinating? Can visual storytelling serve as a testament to and conduit for processes that are both so complex and so necessary, in order to generate intellectual and emotional engagement vis-à-vis the possibilities of survival and prosperity for our species?

In Locatelli's vision, there is a place in Europe that represents the closing of the circle, the standard-bearer for an efficient and potent synergy between mankind and nature: Iceland, the land of volcanoes and the quintessence of the force of nature, and the opening subject of the exhibition. Rich in hydroelectric and geothermal resources, Iceland generates 100% of its electricity from clean energy, for both private and industrial consumption. This energy synergy powers, amongst other industries, the production chain for the food of the future. The images and videos in this first section of the exhibition describe the manufacture of astaxanthin, a carotenoid found in nature, produced by the microalgae *Haematococcus pluvialis* as a defence mechanism against challenging environmental conditions (for human beings,

astaxanthin is one of the most powerful natural antioxidants known to man, with numerous benefits for health, supported by wide-ranging scientific research, including clinical studies on human subjects). This initial section covers the production of algae both for human consumption and as fish food, in a facility integrated with one of the largest geothermal plants in the world, which makes it possible to transform the waste from the plant itself into sustainable resources for the manufacturing process.

Also highlighted here is the possibility for the natural and permanent storage of carbon dioxide, transforming the CO_2 into stone in the subsoil, in a production cycle of less than two years. The majestic images of Iceland capture a vibrant dialogue between technological innovation and elemental power, and they relate in turn to an Italian story – that of Larderello, in Tuscany, the site of the world's first geothermal plant in 1911. Today, Larderello is home to Europe's largest geothermal plant, in Valle Secolo, which has a total installed capacity of 120 MW. It is estimated that Italy has potential extractable and exploitable geothermal energy resources of between 500 million and 10 billion tonnes of oil equivalent; in other words, between 5,800 and 116,000 terawatt-hours of energy, against a current annual requirement of just over 300 terawatt-hours.

The central part of the exhibition constitutes a spectacular and fascinating journey into the bowels of abandoned mines now converted into theme parks or hyper-efficient datacenters. Here, a transmedia approach documents an extraordinary example of the salvaging of a former open-cast coal mine in the state of Saxony-Anhalt (Germany), today a venue for musical events and a member of the New European Bauhaus. In this room, the relationship between mankind and machine, intellect and industrial production is represented by practices of brownfield/industrial regeneration and the recovery of raw materials: from the sorting and processing of non-wearable textiles which are given a second life to the recycling of fishing nets for the manufacture of a special type of nylon, used by the leading fashion houses, to the production of paper made from algae that infest the Venetian lagoon. Innovative systems are illustrated for the dismantling and smart recycling of end-of-life aeroplanes, and we get to learn all about insect rearing in Piedmont for the production of natural fertilizers and potentially for use as animal and human foodstuffs – the next frontier for the development of circular and sustainable food.

Making our way through a breathtaking immersive showcase of the first high-altitude solar farm built on the Lac des Toules, Switzerland, we move towards the nature-based solutions of the undersea world, which provide perspectives on food, agriculture and the key to life on earth – photosynthesis. Experiments of underwater agriculture in Liguria then lead to the farming of mussels off the

coast of Galicia, carried out on floating wooden frames with ropes suspended in the water column on which the mussels grow. These operations are renowned for increasing the biodiversity of the water column, offering shelter to the fauna and anchorage to the macroalgae, while also filtering the seawater: the molluscs position themselves on the lowest level of the food chain as filter feeders, living off the microscopic organic material present in the surrounding water. The exhibition route duly closes its own circle with a collection of video material summarising the subjects on show.

Along the entire exhibition route, there are interactive and static infographics, produced by the designer Federica Fragapane in collaboration with Locatelli. These impressive visuals represent the thread that binds the photographic story to the intellectual experience, between vision and information. An increasingly common feature of the exhibition environment, experimental infographics of this type offer opportunities that are only beginning to be explored and are targeted at summoning up a transmedial museum experience, and the presentation of *the CIRCLE* in the spaces of Gallerie d'Italia - Torino constitutes an ideal test run.

Conceptually, *the CIRCLE* represents the first, fundamental chapter of a research project that aims to be rolled out across the planet's other five continents, in the hope of constructing a pathway and a discourse with a humanistic slant. The stories describe real experiences of nature-based solutions: actions undertaken to protect, support and reinstate natural ecosystems that, when applied to industrial and manufacturing models, have the potential to trigger that cultural transformation which is a *sine qua non* if the course of events is to be changed. The images, accompanied by a wealth of explanatory infographics and texts, describe experiences and situations in which highest-level engineering, craftsmanship and ancestral knowledge go hand-in-hand to create a space in which Nature returns to become the centre and pivot point of the equilibriums, and in which human knowledge and understanding are made available to environmental forces in order to benefit from their power, without trying to tame or imprison them. These are the nature-based solutions that, more than any others, offer us the greatest chance of success. They show us how the most futuristic technologies and the intuitive leap of self-generation can both contribute to achieving the same end – the closing of the circle, the possibility of a perpetual system.

The possibility of success.

1 Isabel Mendes, *The Circular Economy: an Ancient Term that Became Polysemic. Working Papers*, Universidade de Lisboa, 2020, https://www.repository.utl.pt/bitstream/10400.5/20883/1/WP022020.pdf

The SNR-300 was a fast breeder sodium-cooled reactor located in Kalkar, in the state of North Rhine-Westphalia in Germany. Completed shortly before the 1986 explosion at Chernobyl, it never went into operation due to construction problems and protests.

Acquired in 1995, the site was transformed into an amusement park and now attracts around 600,000 visitors a year. Many of the structures built for the reactor have been integrated into the park and its attractions, including the cooling tower, in which a swing carousel and a climbing wall have been installed. The park also has four restaurants, eight bars and six hotels.

2050 Nuclear Ride,
Germany, 2015

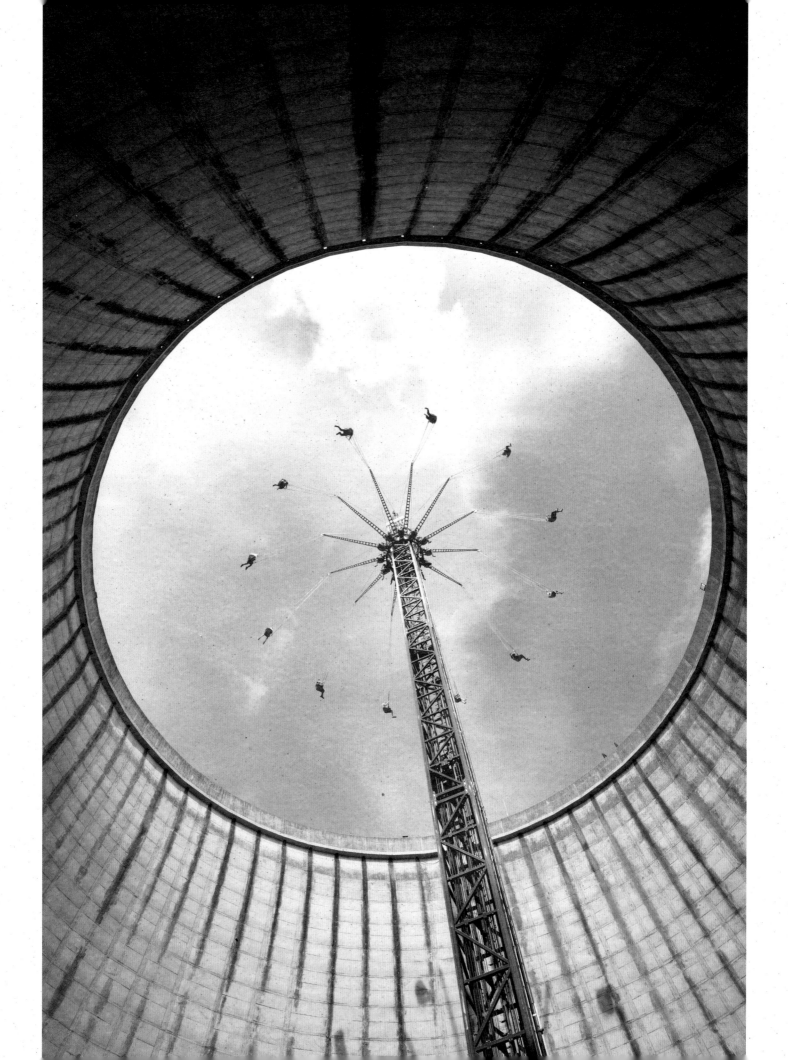

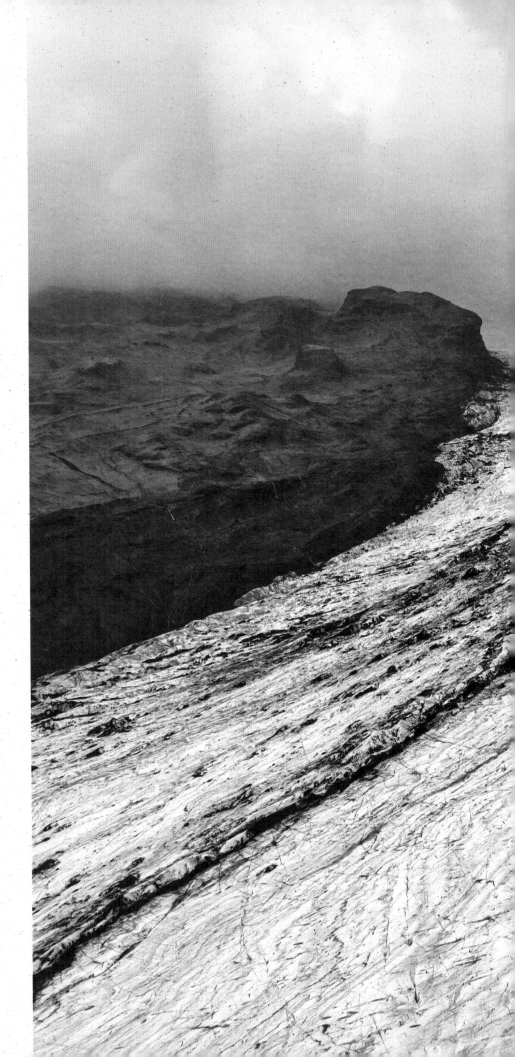

ICELAND

CO_2

Nature Power Glacier #1,
Iceland, 2022

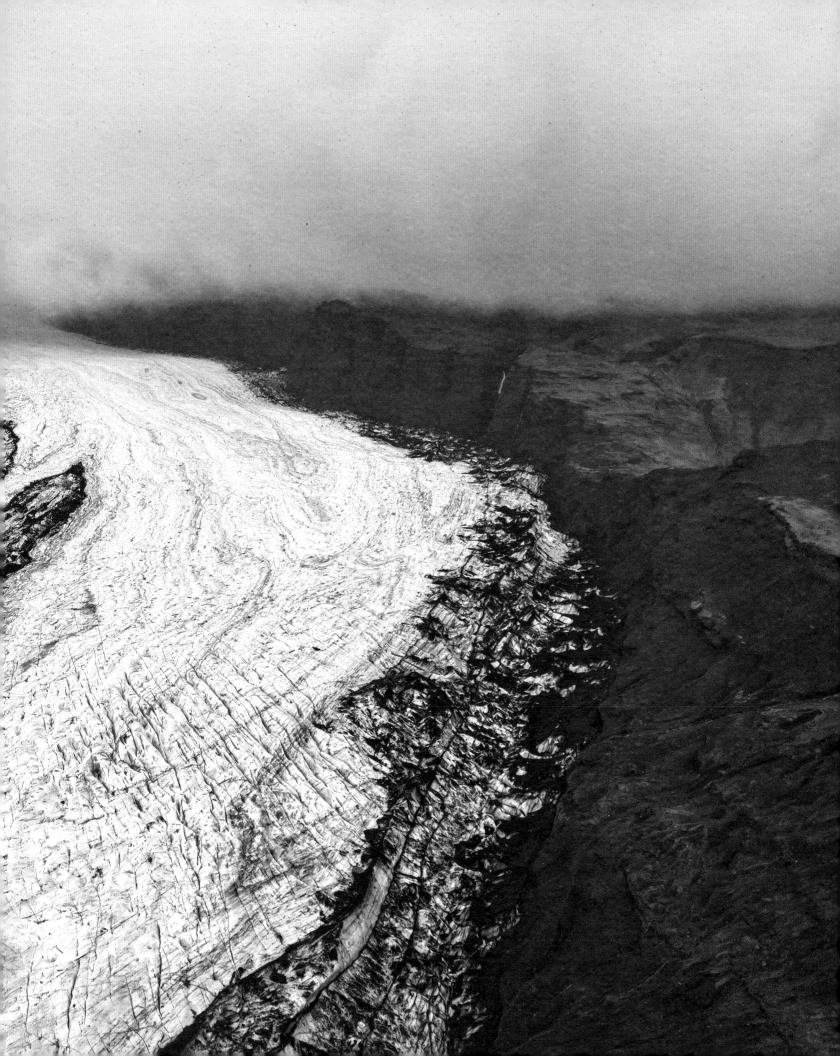

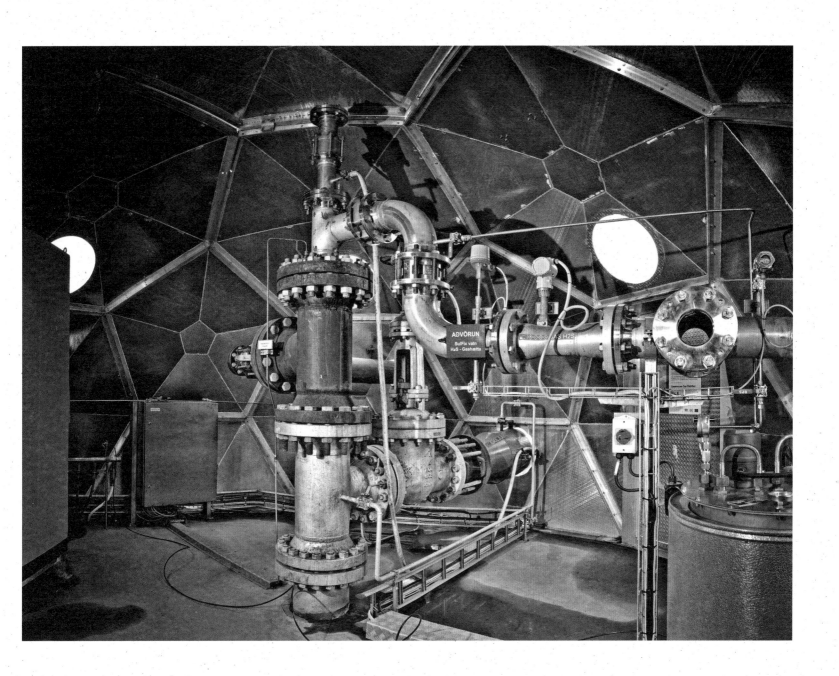

Nature Power Waterfall #1,
Iceland, 2022

Carbon Capture Machine #1,
Iceland, 2022

Following pages
Carbon Capture Machine #2,
Iceland, 2022

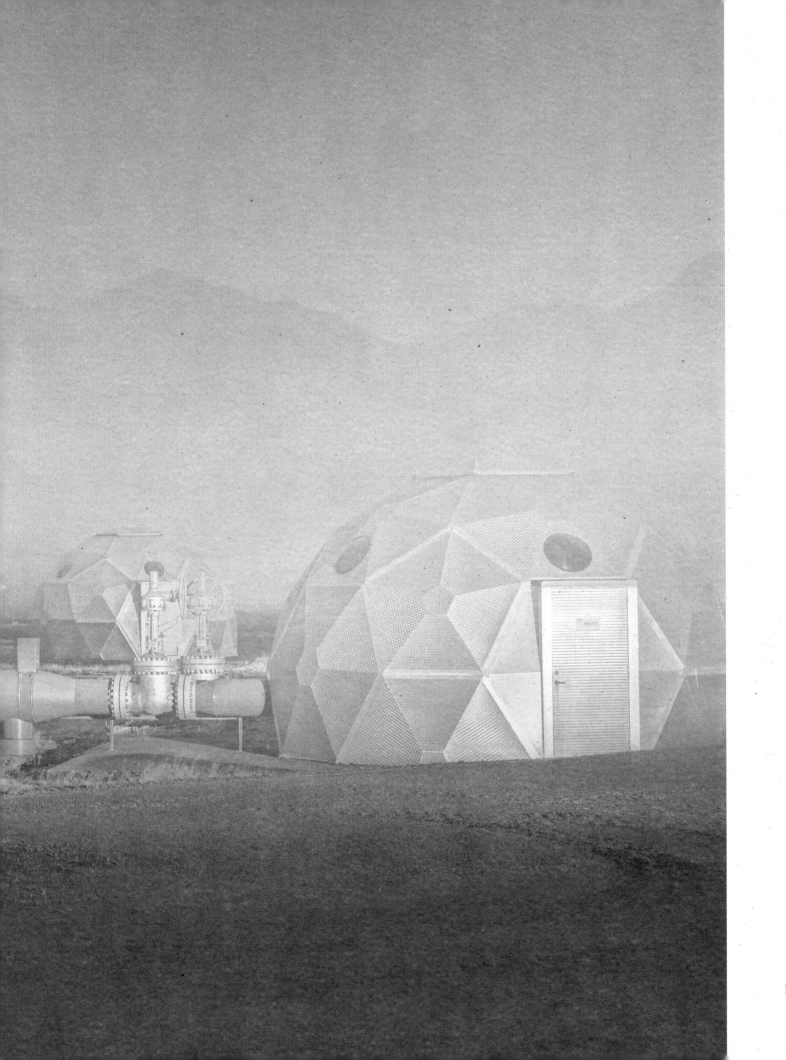

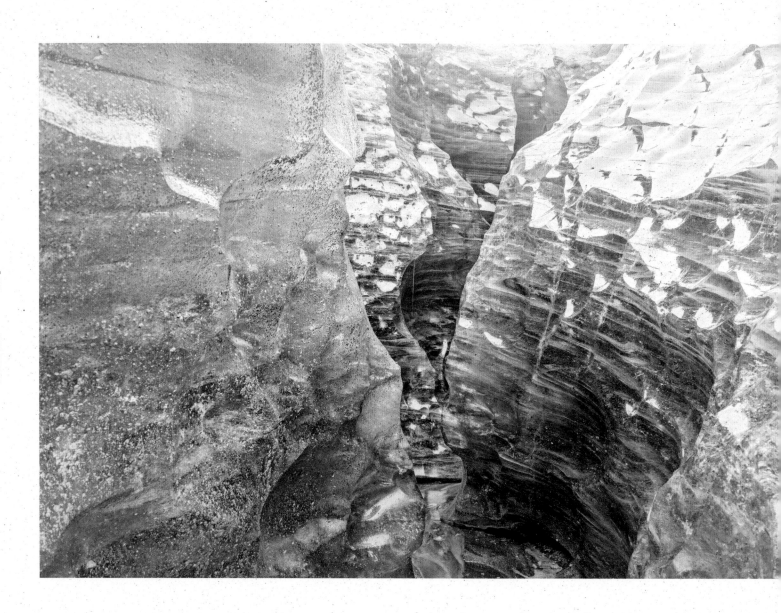

Nature Power Glacier #2,
Iceland, 2022

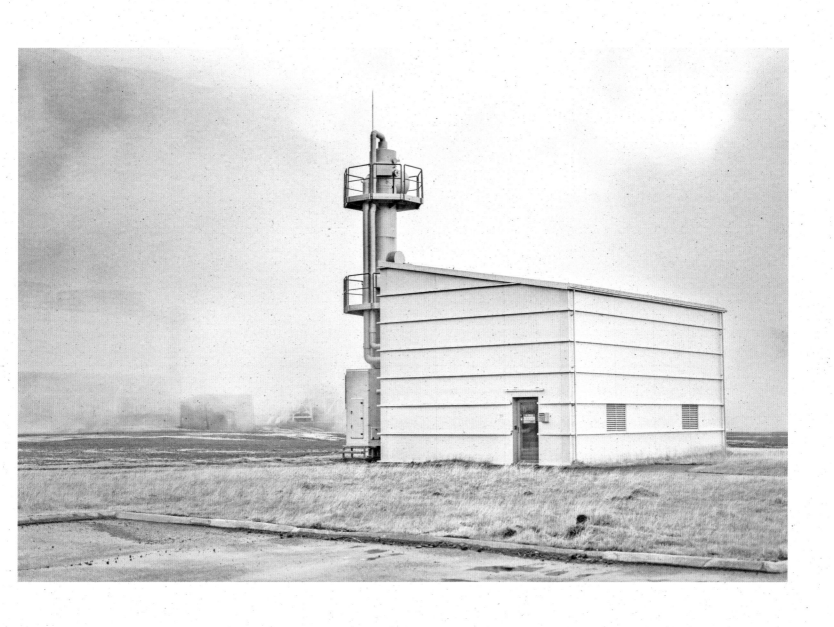

Carbon Capture Machine #3,
Iceland, 2022

Following pages
Geothermal Landscape #1,
Iceland, 2019

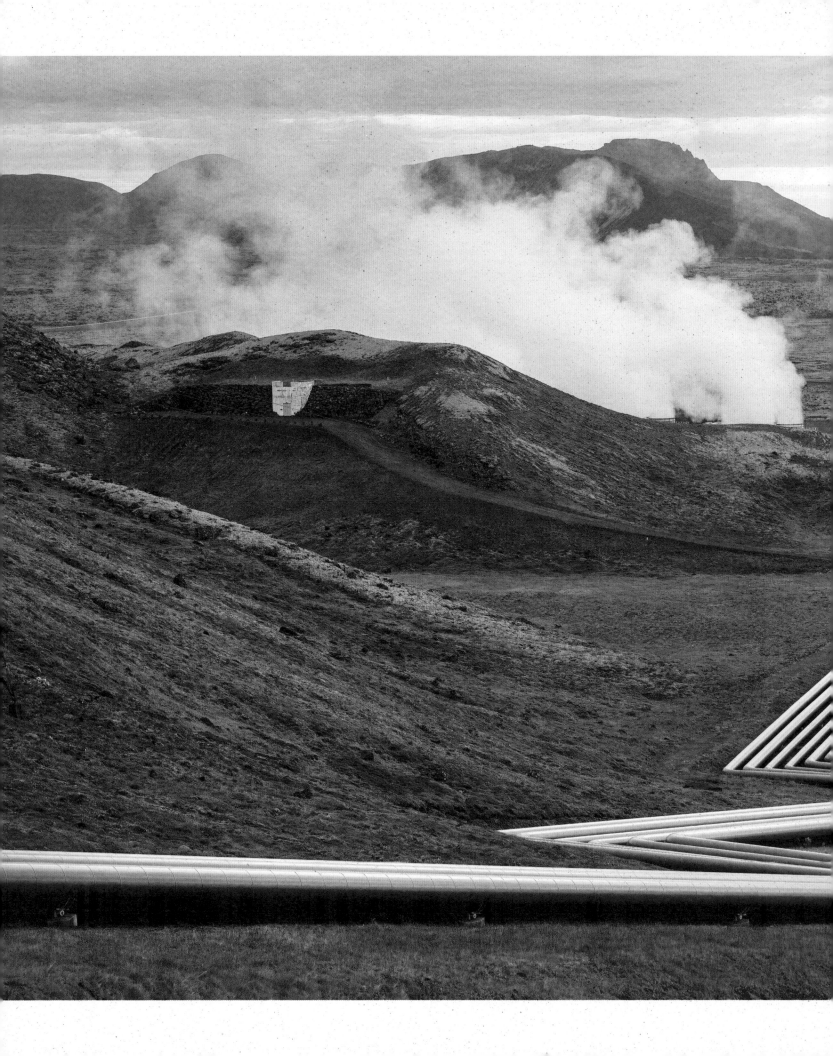

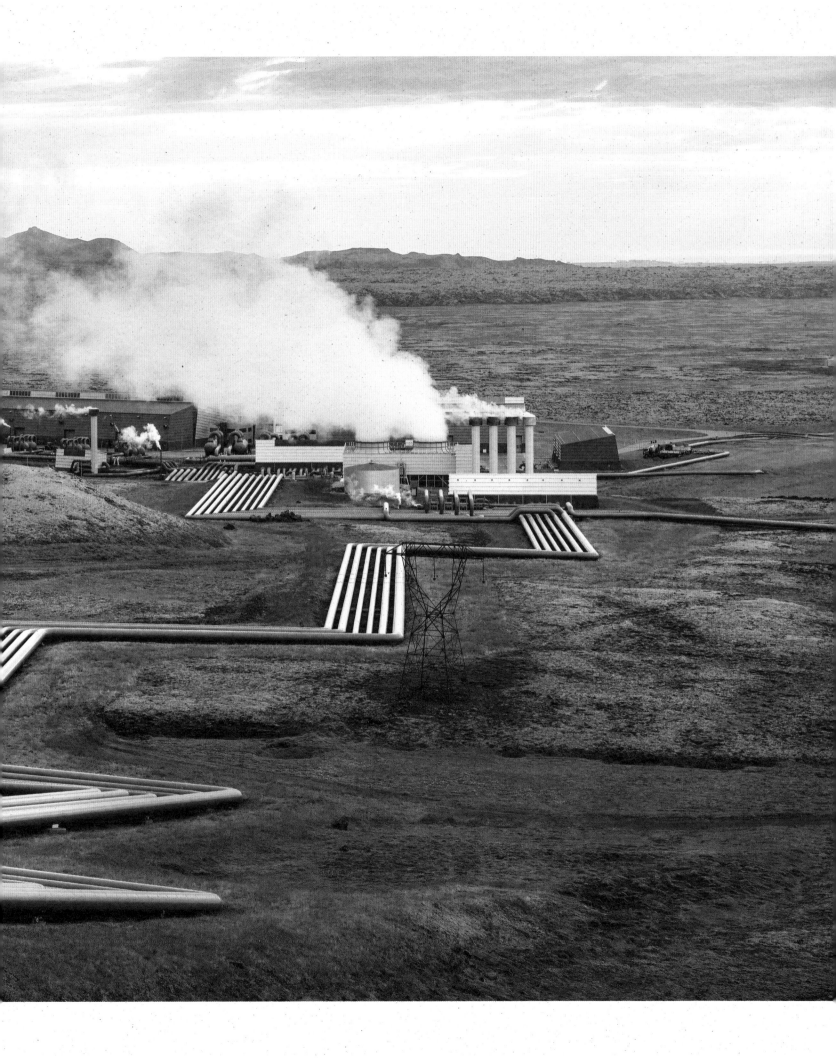

Geothermal power plants use steam from geothermal fields, and this contains a fraction of CO_2, which is released in the electricity production process. The carbon dioxide emitted by the power plant is then dissolved in water in a structure called a scrubber tower. The water charged with CO_2 is injected into the ground via a facility called an injection well, which reaches a depth of over 2,000 metres. The basalt at this depth reacts with the mixture of water and carbon dioxide and, due to the presence of metals, transforms the CO_2 into stone.

Active since 2014, the Hellisheiði geothermal plant currently has a processing capacity of about 12,000 tonnes of CO_2, with a significant annual growth rate.

It has been estimated that the active rift zone in Iceland could store over 400 gigatons (billion tonnes) of CO_2. The theoretical storage capacity of ocean ridges is significantly greater than the 18,500 gigatons of CO_2 that would result from burning all the fossil fuels on earth.

Geothermal Landscape #1,
Iceland, 2022

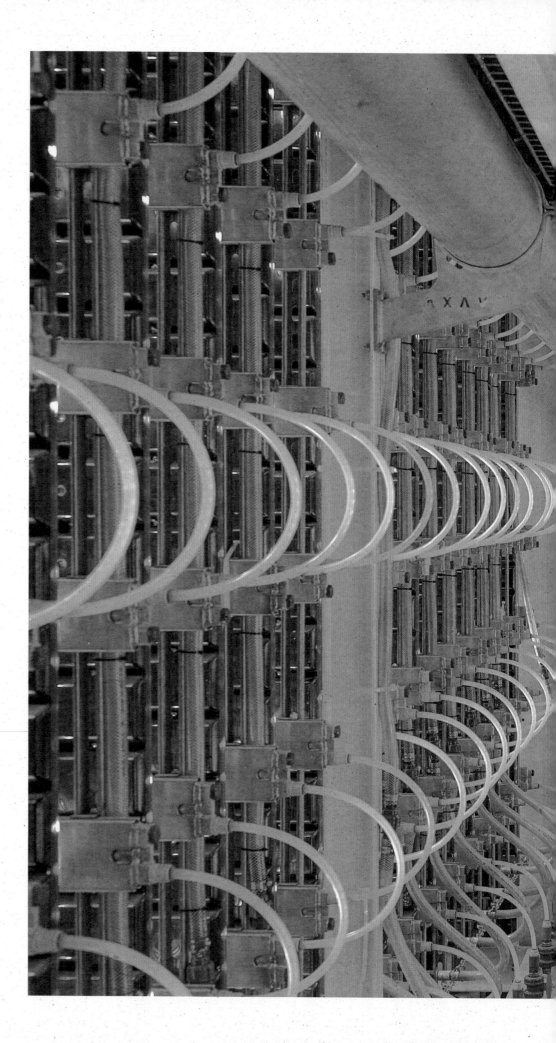

Algae Farm #2,
Iceland, 2022

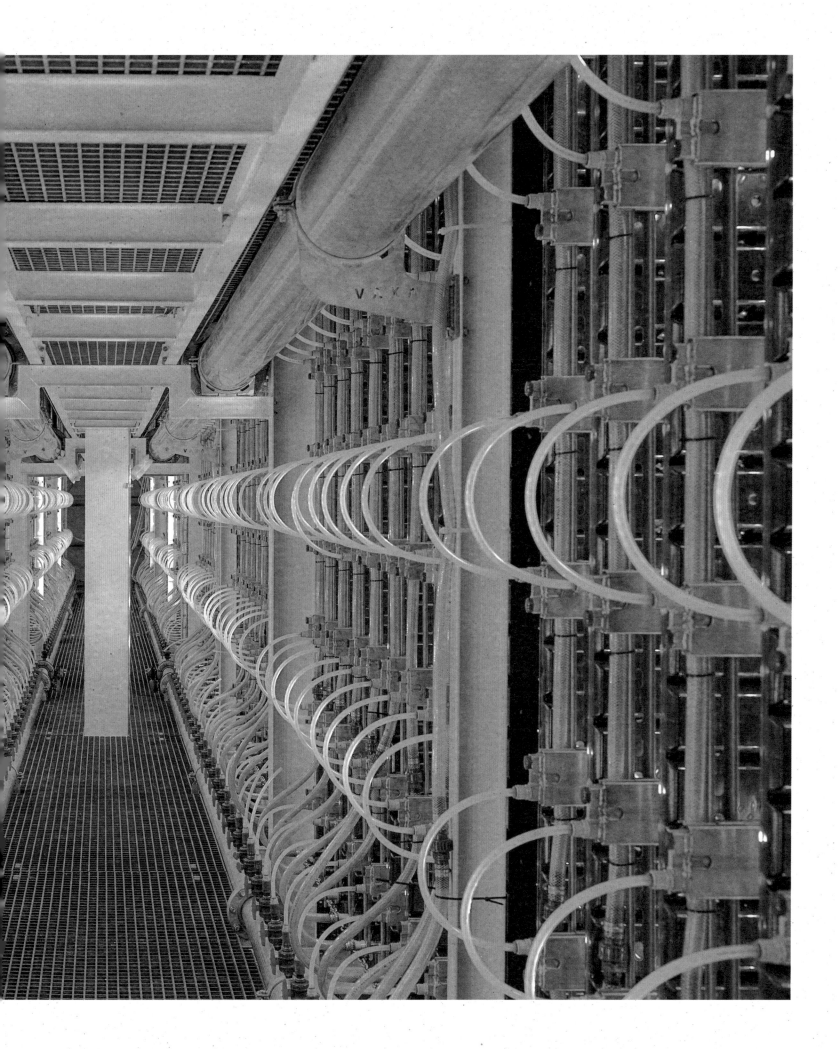

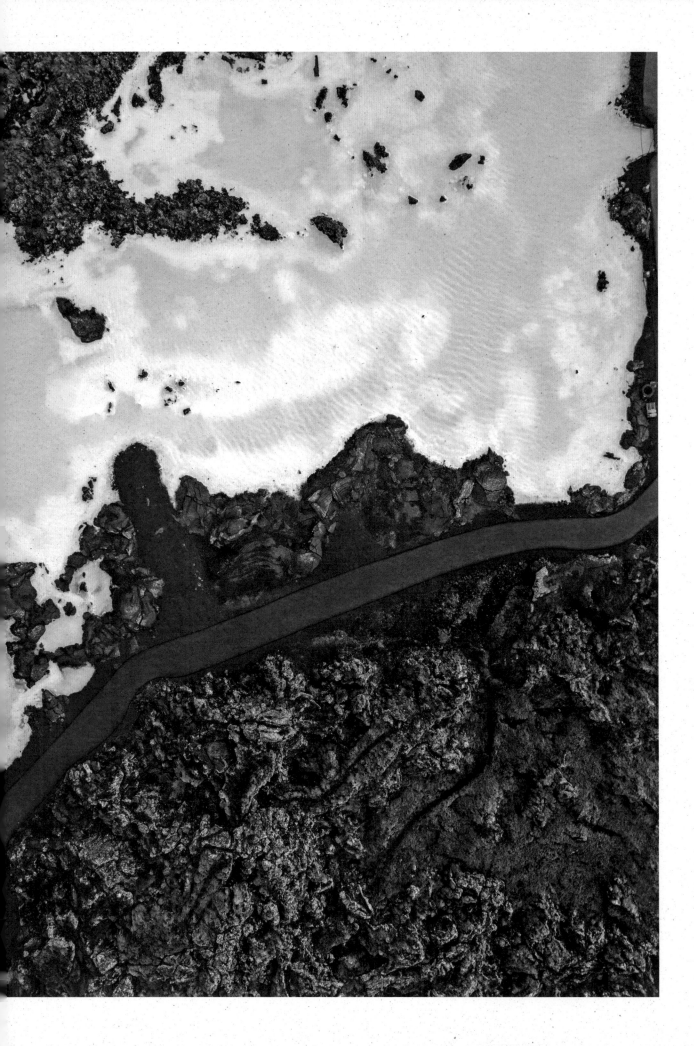

Geothermal Landscape #3,
Iceland, 2022

Geothermal Landscape #2,
Iceland, 2022

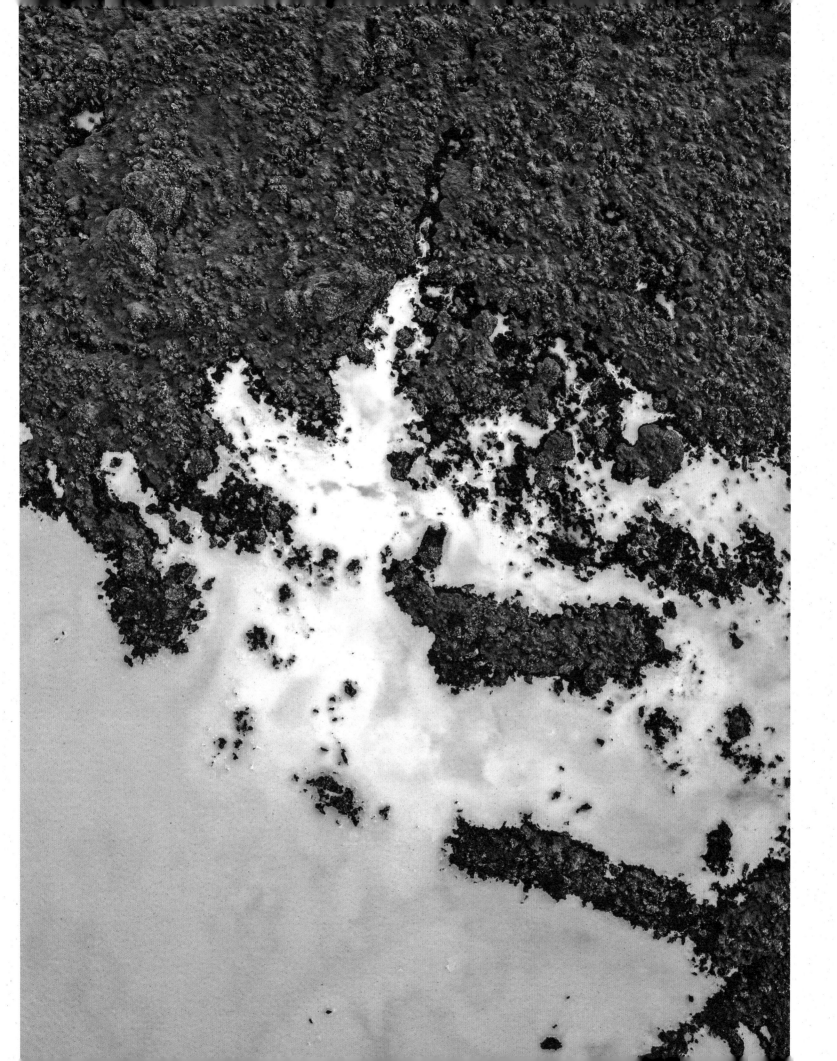

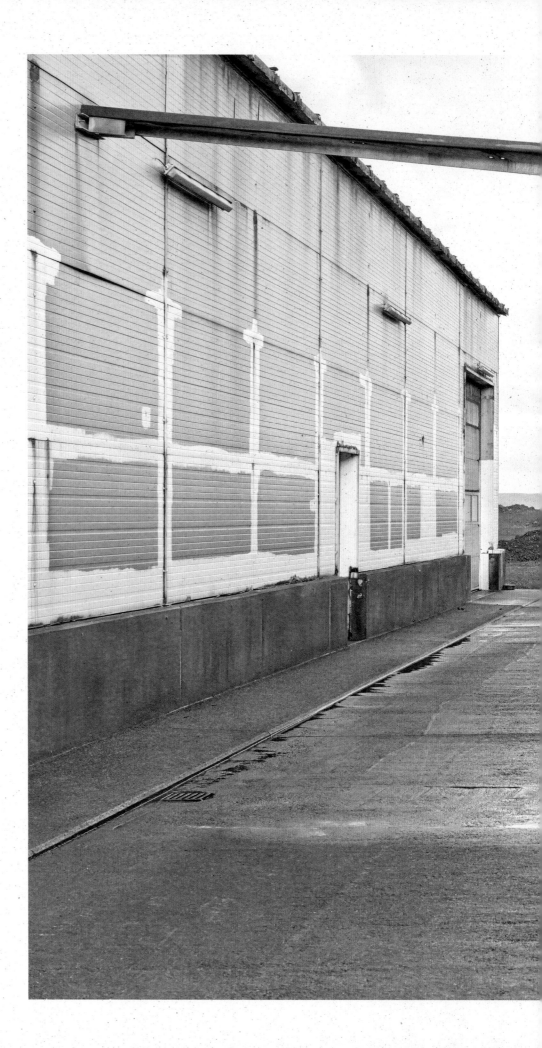

Fishfarm #1, Iceland, 2022

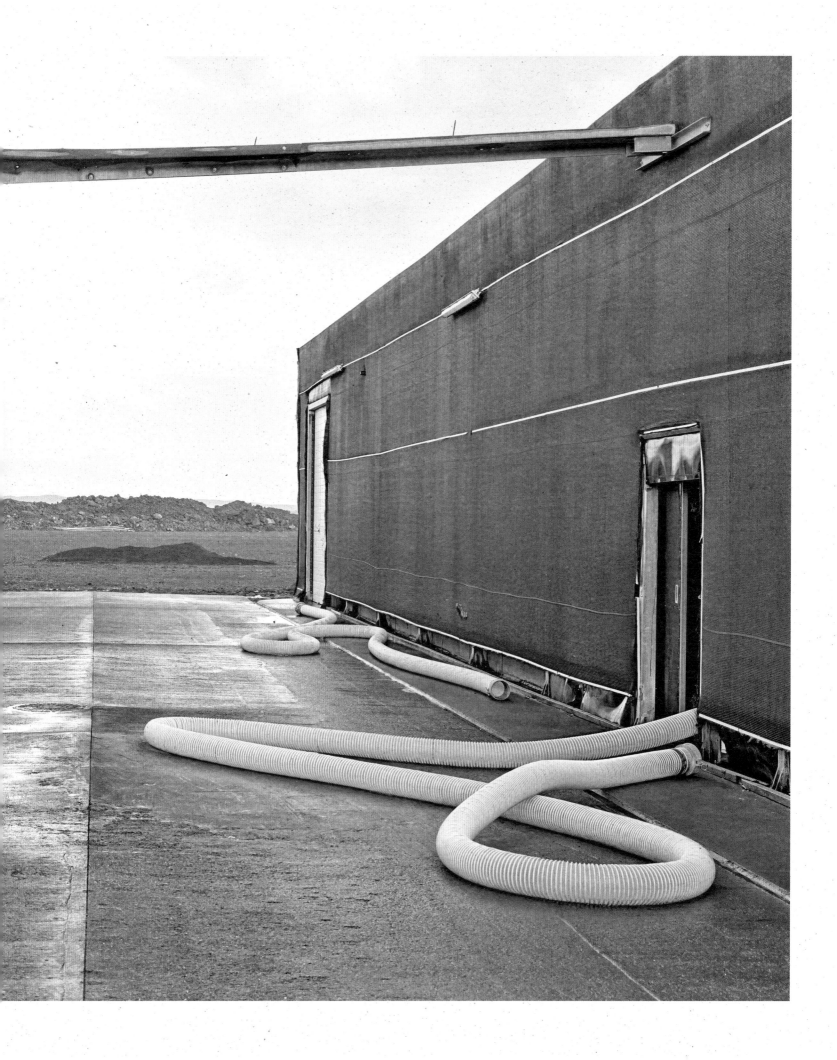

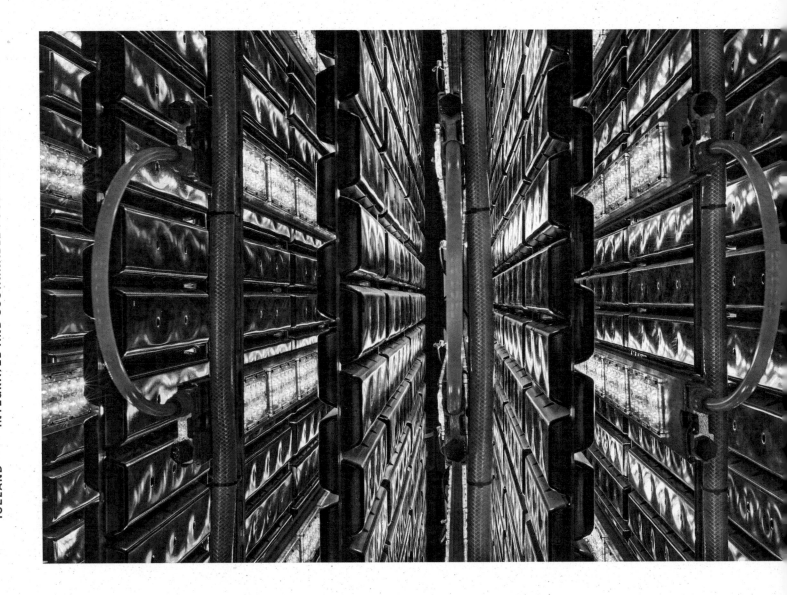

Algae Farm #1, Iceland, 2022 Fishfarm #2, Iceland, 2022

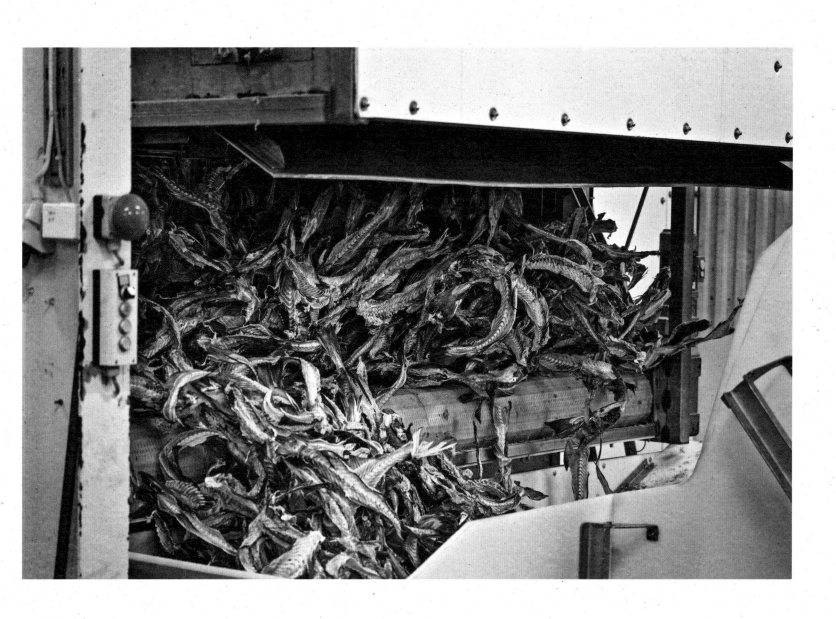

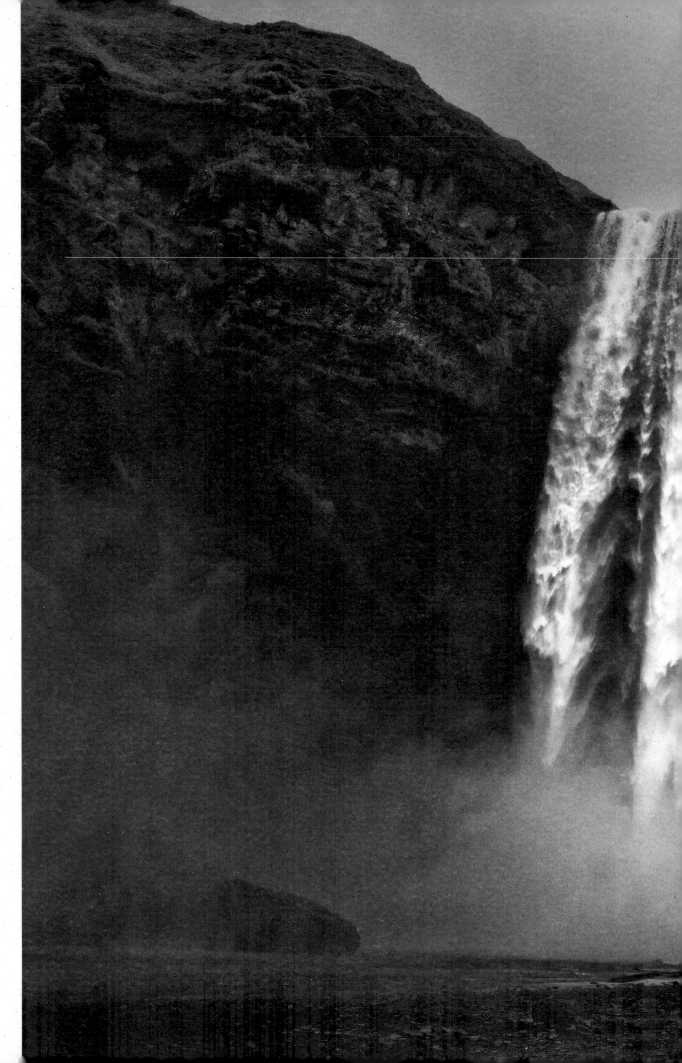

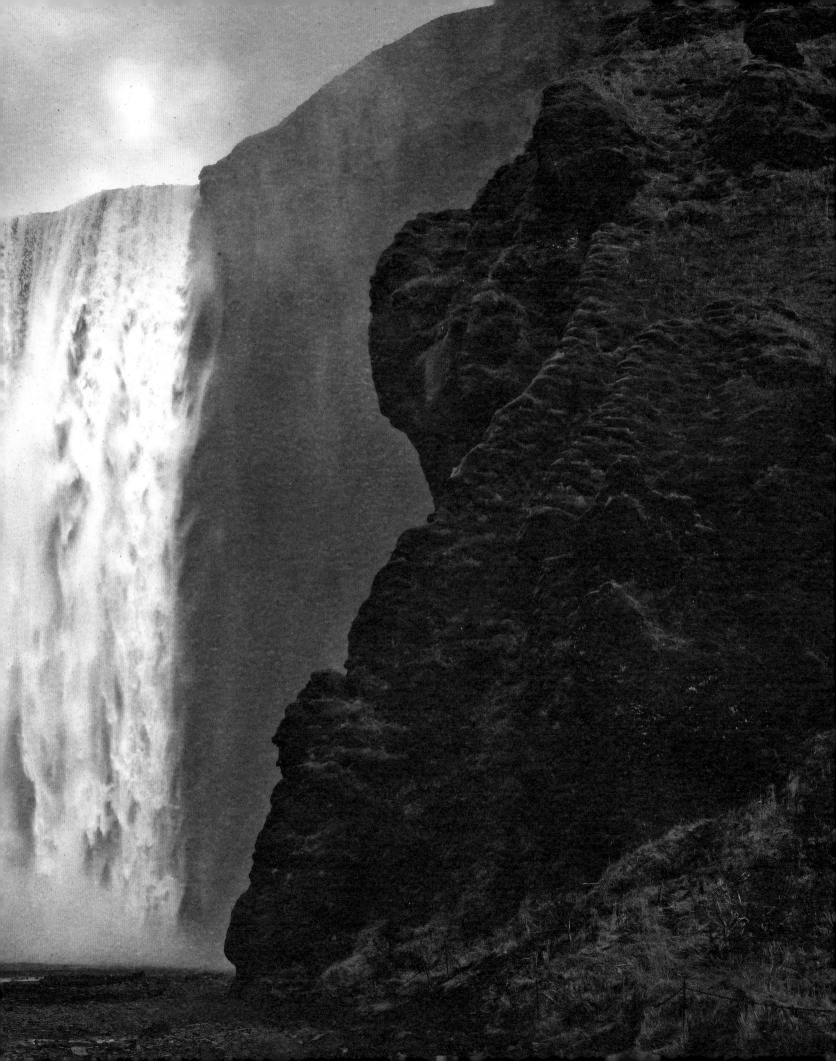

In Iceland, there are several companies actively working in integrated and sustainable food production, many of them associated with geothermal energy production. Rich in hydroelectric and geothermal resources, Iceland generates 100% of its electricity from clean sources.

Algae production (pp. 34–35, 40)

This Icelandic company produces algae for human consumption and as fish food.

Machine-learning technology is used for crop and light management. Production takes place indoors, 24/7, and is fully controlled and optimised for growth. The plant is integrated with one of the largest geothermal plants in the world, whose waste is transformed into sustainable resources for the production process. Clean energy, hot and cold water and natural carbon emissions from the geothermal plant are used to produce the microphytes, making them completely sustainable and carbon-neutral. The production process requires less than 1% of the fresh water and land footprint compared to industry standards.

Sustainable fish farming (pp. 38–39)

This company is at the forefront of sustainable fish farming. Among its key targets to be achieved by 2030 are 0% waste to landfill and the reduction of marine ingredients in fish feed by 65% for sole and 50% for turbot.

The soles are reared in a continuous-flow system fed by water from a geothermal power plant, which gives them access to water at 22 °C without the need for heating, despite the northern location of the farm.

Fish drying (p. 41)

Fish drying is an effective method of food preservation. Dried fish has a shelf life of years. When rehydrated, it regains the qualities of fresh fish.

This company which specialises in the drying of fish production waste is a leader in the development of techniques for drying fish indoors, using geothermal energy.

Volcanic Greenhouse #1, Iceland, 2019

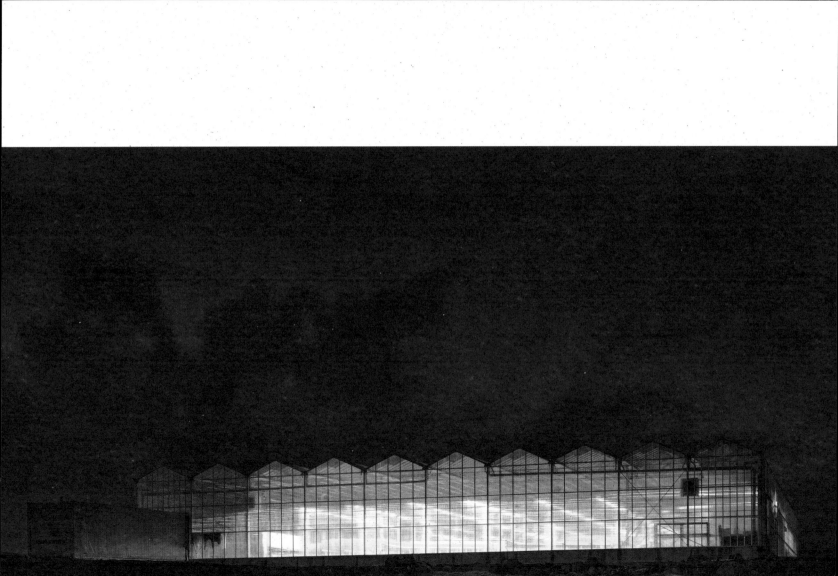

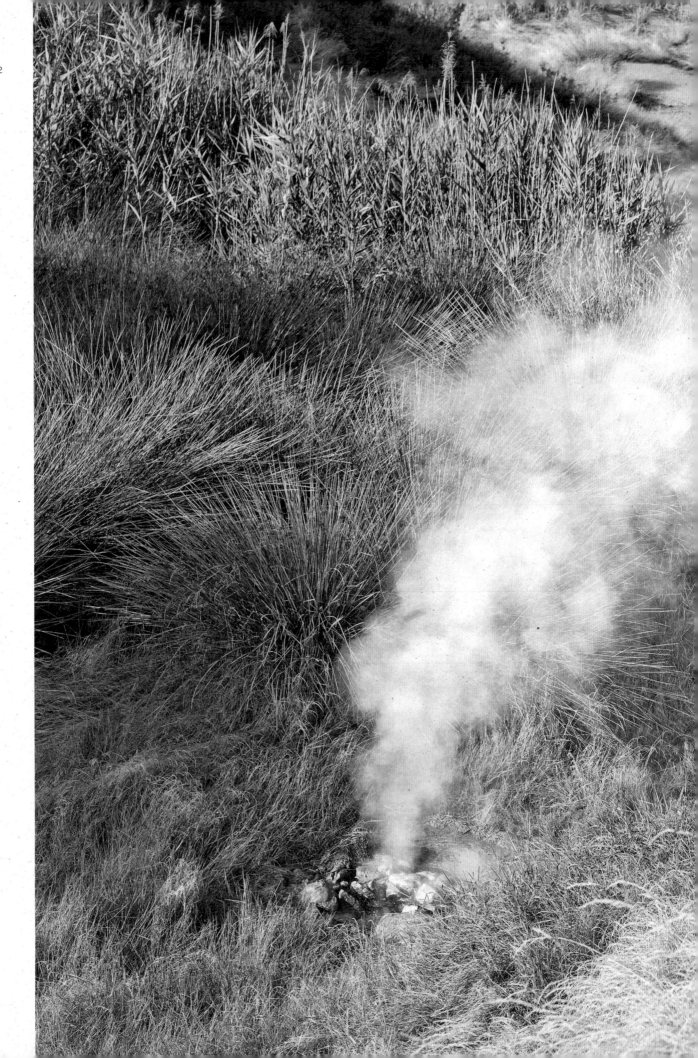

ITALY　　GEOTHERMAL ENERGY

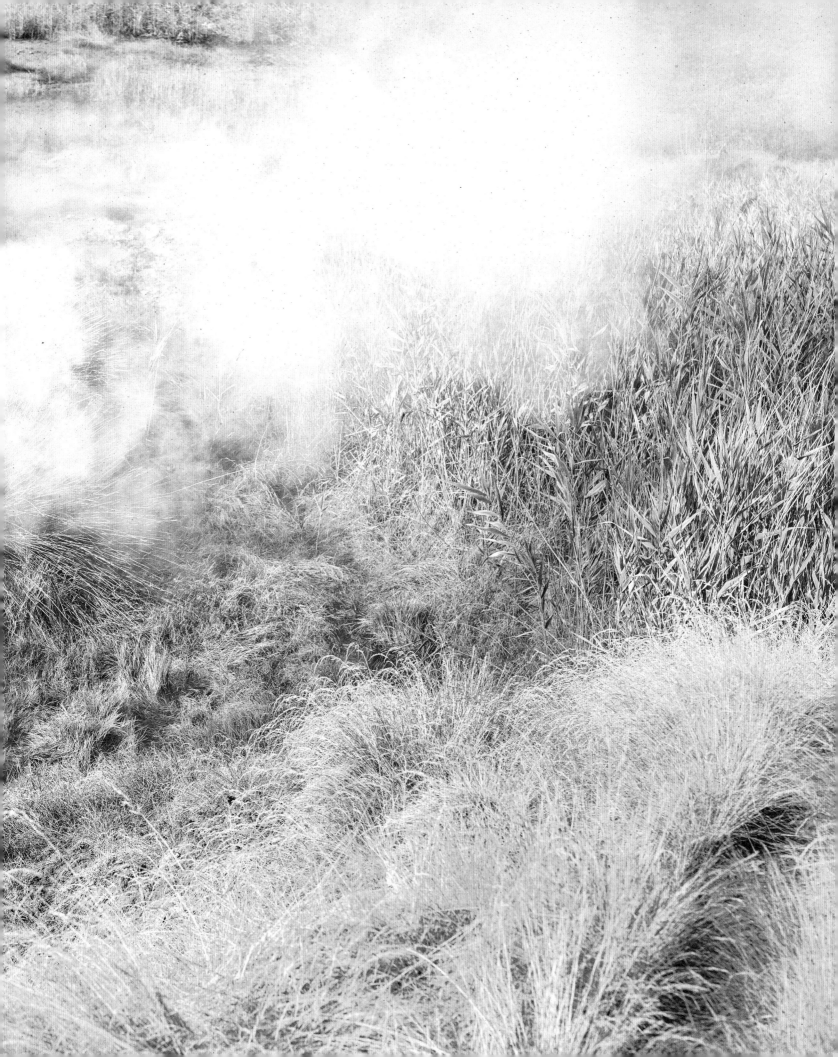

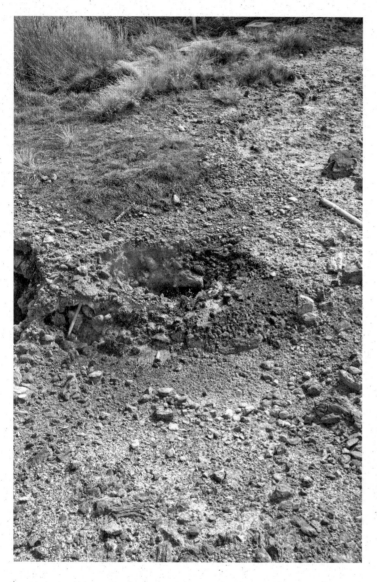

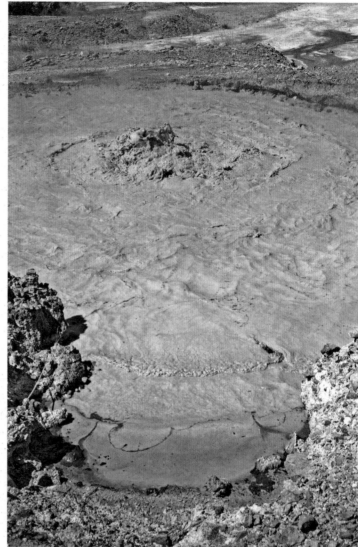

Opposite page
Larderello Geothermal
Landscape #3, Italy, 2022

Larderello Geothermal
Landscape #1, Italy, 2022

Following pages
Larderello Geothermal

Larderello Geothermal
Landscape #6, Italy, 2022

Landscape #2, Italy, 2022

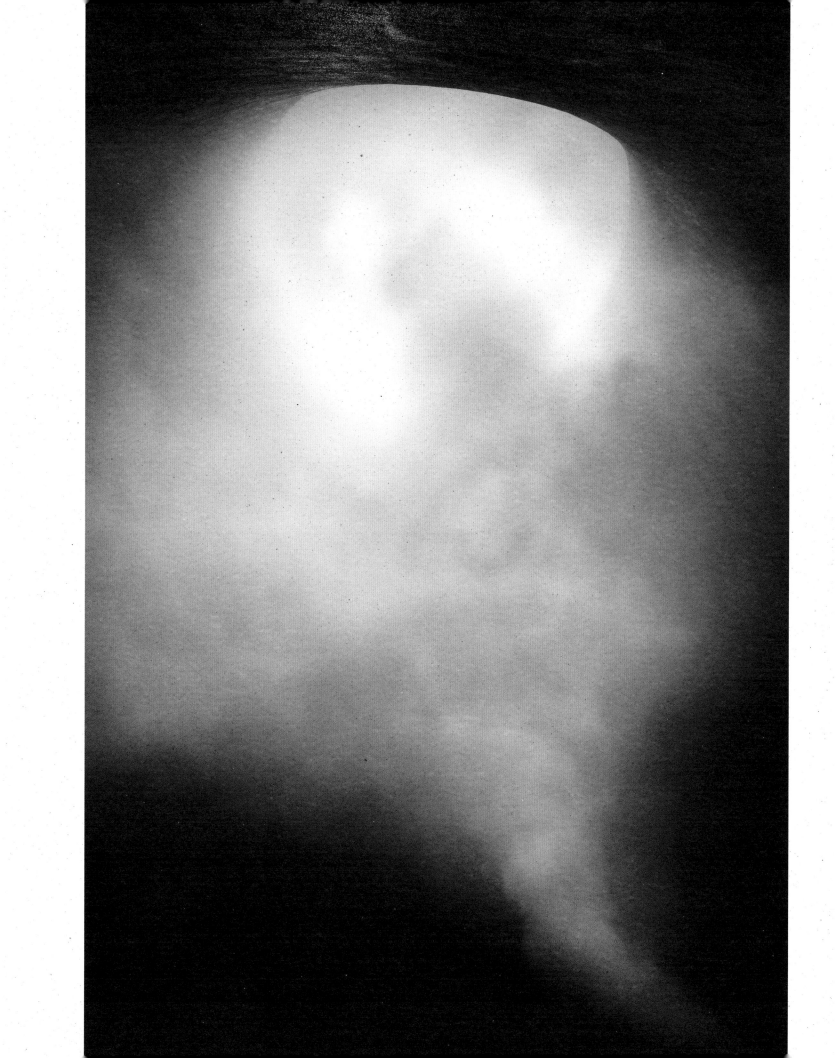

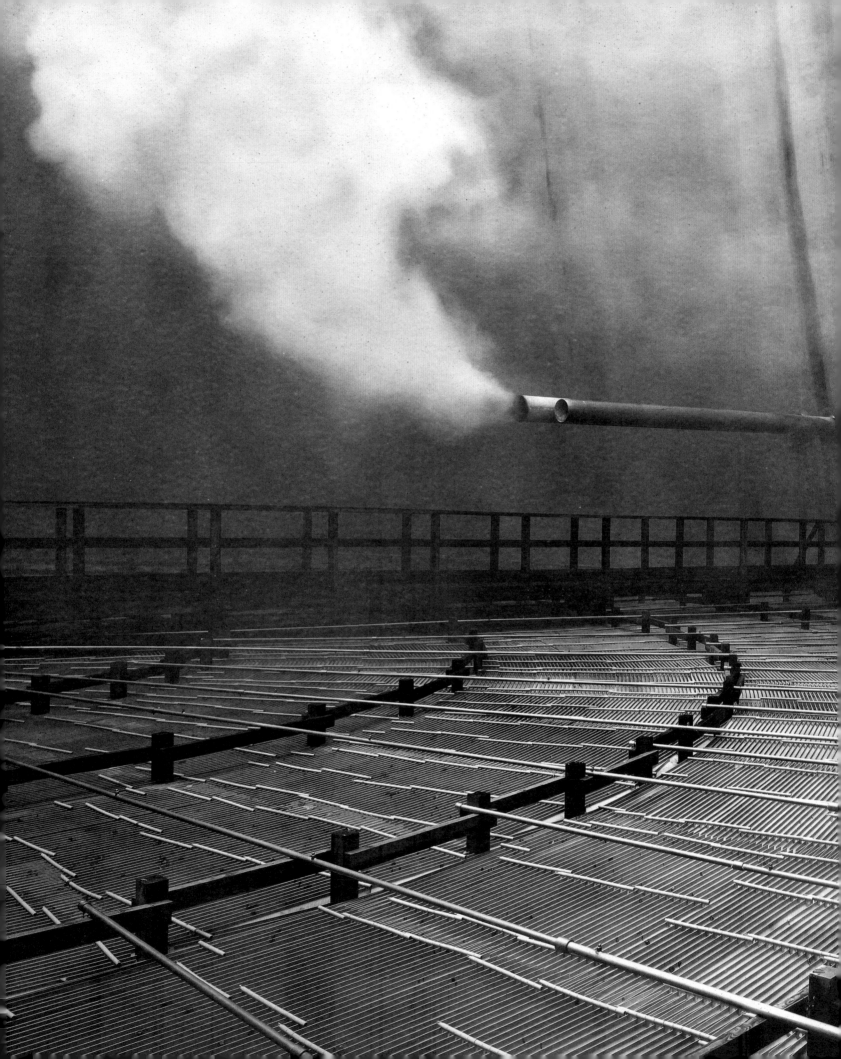

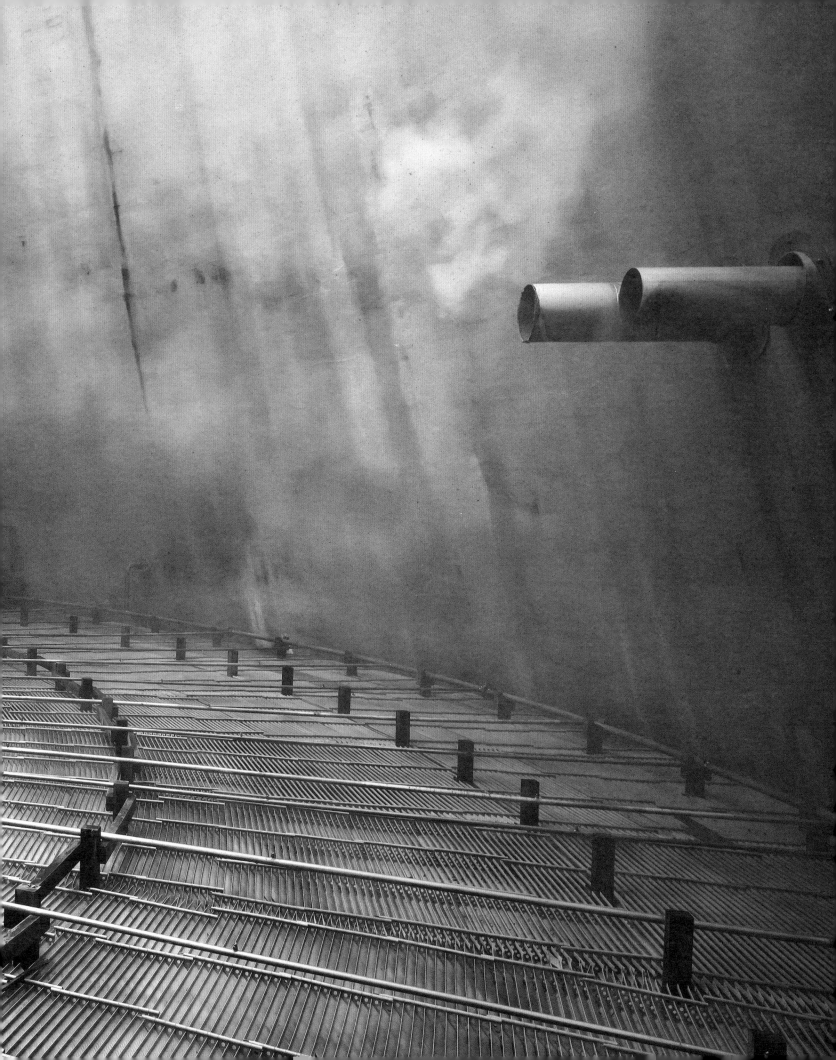

Larderello Geothermal
Landscape #4, Italy, 2022

In 1911, Larderello became the site of the world's first geothermal power plant. By 1916, the plant was able to supply energy to the surrounding area and the city of Volterra.

The Tuscan geothermal district has an installed capacity of 916 megawatts and hosts Europe's largest geothermal power plant with an installed capacity of 120 megawatts.

In the region there are 34 geothermal power plants (for a total of 37 production groups): 16 in the province of Pisa, 9 in the province of Siena and 9 in the Grosseto area. In addition to satisfying more than 30% of the region's electricity needs and representing 70% of the renewable energy produced in Tuscany, the approximately 6 billion kilowatt-hours produced provide heating for almost 10,000 residential users in 9 geothermal municipalities. All this reduces the consumption of oil equivalent by 1.1 million tonnes and the emission of CO_2 equivalent into the atmosphere by 3 megatons, which combined with a heat production of about 454 gigawatt-hours, prevents the emission of another 121,000 tonnes of CO_2 equivalent.

However, the development of the geothermal industry in Tuscany has historically been opposed by part of the population and experts in the sector. As noted by the Regional Health Agency of Tuscany: "in addition to pollutant emissions, geothermal exploitation can at times be accompanied by problems of subsidence (lowering of the ground), interference with natural seismicity, interaction with hydrogeological resources, noise pollution for plant workers, and alterations to the landscape". The Italian example presents many issues regarding sustainability and effectiveness that are still being resolved.

Italy has a potential of extractable and exploitable geothermal energy that is estimated to be worth between 500 million and 10 billion tonnes of oil equivalent, i.e. between 5,800 and 116,000 terawatt-hours of energy, against an annual requirement of just over 300 terawatt-hours.

DATA

INFORMATION DESIGN FEDERICA FRAGAPANE

The circle is the emblem of a philosophical paradigm: circularity. The natural distillation of the set of ideas and characteristics associated with the figure of the circle, circularity connotes an approach aligned with the immutable laws of nature, balanced and equidistant, resolved. This notion has found one of its most significant contemporary expressions in economic theory, understood as the opposition to linearity, based on a model of consumption and exponential growth that is unsustainable. The circular economy is developed with the intention of addressing the problems caused by the linear development of economic, production and social activities, proposing potential long- and short-term solutions. It is a production and consumption model that involves sharing, lending, reusing, repairing, reconditioning and recycling existing materials and products for as long as possible in order to protect and regenerate natural resources. Climate change, agricultural and industrial production, and individual consumption are just some of the causes that deplete the planet's resources well before they can be regenerated. Moreover, the profound disparity between wealthy countries and those that are poor causes the scarce resources at our disposal to be squandered in large part by the very countries that cause them to dry up. Every year we run out of available planetary resources earlier than the year before, borrowing what we need from the following year – without ever returning to a break-even point. The moment we run out of resources every year is called Earth Overshoot Day (EOD), and for 2023 it was 2 August. It is like having just one bottle of water available for the whole day and having to make it sufficient for four

people. One of these people uses it all up indiscriminately before the day is over and, in order to survive, you have to open the next day's bottle. This happens every day, while the water runs out earlier and earlier.

The regeneration of resources (materials, waste), a greater awareness of consumption, and eliminating greenhouse gas emissions as much as possible are key factors in the transition to a circular balance, rooted in the identification of nature-based solutions. Nature-based solutions are those strategies that tap into the power and potential of natural processes, which are key to building a circular future. The European Commission defines nature-based solutions as "solutions inspired and supported by nature, which are cost-effective, provide simultaneous environmental, social and economic benefits and help build resilience. These solutions bring greater quantity and diversity of nature and natural features and processes into cities, landscapes and seas through systemic, locally adapted and resource-efficient interventions".

Drawdown Project: Solutions to Reducing Greenhouse Gases

Drawdown is a collaborative project involving researchers and advisors who came together to model the most substantive solutions to reversing global warming.

The visualisation presents the individual solutions reviewed and assessed by Project Drawdown. The solutions are grouped according to relevant sectors, and for each solution, their impact on reducing heat-trapping gases is displayed.

This list is extensive but not exhaustive, and Project Drawdown continues to add to it as a living project.

Project Drawdown uses different scenarios to assess what determined, global efforts to address climate change might look like. Both scenarios shown here are plausible and economically realistic.

* *Drawdown Scenario 1* is roughly in line with 2 ˚C temperature rise by 2100, while *Drawdown Scenario 2* is roughly in line with 1.5 ˚C temperature rise at century's end. The results shown here are based on projected emissions impact globally. The relative importance of a given solution can differ significantly depending on context and particular ecological, economic, political or social conditions.

Source: drawdown.org. Consulted July 2023.

Legend

Each group is a sector, each branch is a solution (some of the solutions may be included in more than one sector)

Area of the circles = gigatons of CO_2 equivalent reduced/sequestered, 2020–2050.
CO_2 equivalent is a measure used to compare the emissions from various greenhouse gases based upon their global warming potential (GWP)

100 80 60 40 20

Colour of the circles = scenario

● Scenario 1*

○ Scenario 2*

╱ Data not available

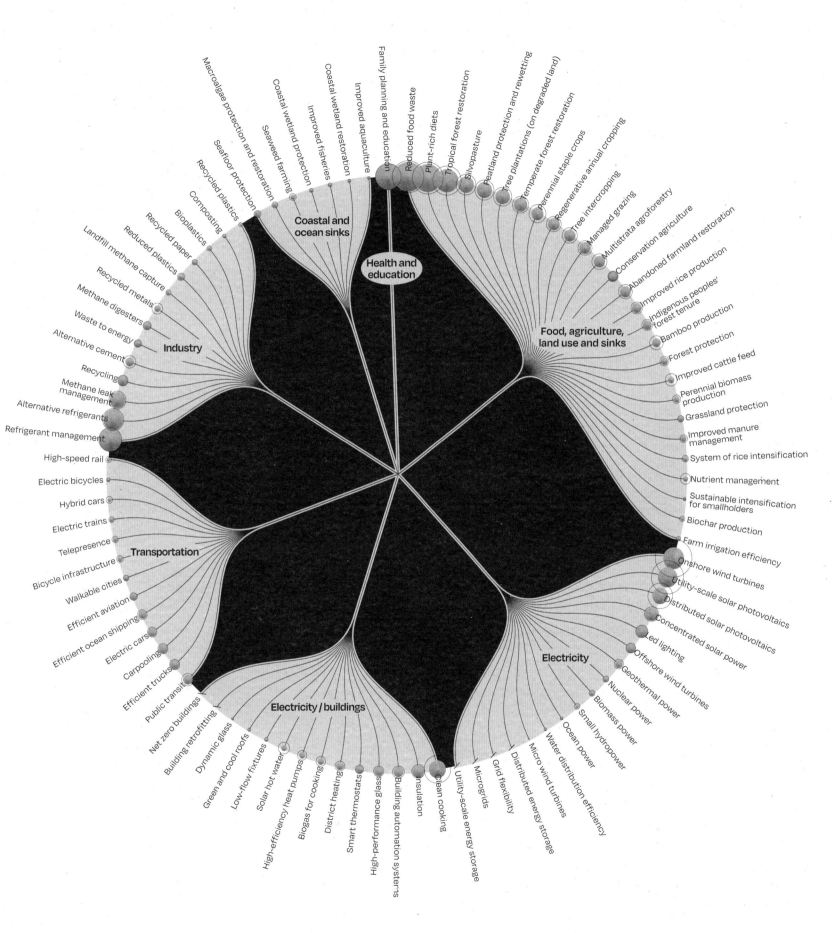

Family planning and education
Reduced food waste
Plant-rich diets
Tropical forest restoration
Silvopasture
Peatland protection and rewetting
Tree plantations (on degraded land)
Temperate forest restoration
Perennial staple crops
Regenerative annual cropping
Tree intercropping
Managed grazing
Multistrata agroforestry
Conservation agriculture
Abandoned farmland restoration
Improved rice production
Indigenous peoples' forest tenure
Bamboo production
Forest protection
Improved cattle feed
Perennial biomass production
Grassland protection
Improved manure management
System of rice intensification
Nutrient management
Sustainable intensification for smallholders
Biochar production
Farm irrigation efficiency
Onshore wind turbines
Utility-scale solar photovoltaics
Distributed solar photovoltaics
Concentrated solar power
Led lighting
Offshore wind turbines
Geothermal power
Nuclear power
Biomass power
Small hydropower
Ocean power
Water distribution efficiency
Micro wind turbines
Distributed energy storage
Grid flexibility
Microgrids
Utility-scale energy storage
Clean cooking
Insulation
Building automation systems
High-performance glass
Smart thermostats
District heating
Biogas for cooking
High-efficiency heat pumps
Solar hot water
Low-flow fixtures
Green and cool roofs
Dynamic glass
Building retrofitting
Net zero buildings
Public transit
Efficient trucks
Carpooling
Electric cars
Efficient ocean shipping
Efficient aviation
Walkable cities
Bicycle infrastructure
Telepresence
Electric trains
Hybrid cars
Electric bicycles
High-speed rail
Refrigerant management
Alternative refrigerants
Methane leak management
Recycling
Alternative cement
Waste to energy
Methane digesters
Recycled metals
Landfill methane capture
Reduced plastics
Recycled paper
Bioplastics
Composting
Recycled plastics
Seafloor protection
Seaweed farming
Coastal wetland protection
Improved fisheries
Coastal wetland restoration
Improved aquaculture
Macroalgae protection and restoration

Coastal and ocean sinks

Health and education

Food, agriculture, land use and sinks

Electricity

Electricity / buildings

Transportation

Industry

Mitigation Potential from Various Ocean-Based Activities:
Potential Annual Greenhouse Gas Emissions Reductions by 2050

The visualisation shows the findings of the report *The Ocean as a Solution to Climate Change: Five Opportunities for Action*. The report quantified, for the first time, the mitigation potential of various categories of coastal- and ocean-based activities, including:
1) Ocean-based renewable energy, including offshore wind and other energy sources, such as wave and tidal power;
2) Ocean-based transport, including freight and passenger shipping;
3) Coastal and marine ecosystems, including protection and restoration of mangroves, salt marshes, seagrass beds and seaweeds;
4) Fisheries, aquaculture and dietary shifts away from emission-intensive landbased protein sources (e.g. red meat) towards low-carbon, ocean-based protein and other sources of nutrition;
5) Carbon storage in the seabed.

The annual emission reduction potential of these five categories of ocean-based activities is 21% of the total GHG emission reductions that are needed to achieve the 1.5 °C target by 2050. The experts deemed actions in the first four categories worth pursuing immediately. However, they cautioned that the fifth, carbon storage in the seabed, warranted more research and development to better understand its environmental impacts and long-term efficacy.

Source: United Nations Climate Change, *Ocean and Climate Change Dialogue to consider how to strengthen adaptation and mitigation action*, presentation by Jane Lubchenco. Consulted July 2023.

Legend

Each shape is an ocean-based activity

The number of lines is proportional to the potential maximum annual emissions reduction, gigatonne of carbon dioxide equivalent ($GtCO_2e$).

CO_2 equivalent is a measure used to compare the emissions from various greenhouse gases based upon their global warming potential (GWP)

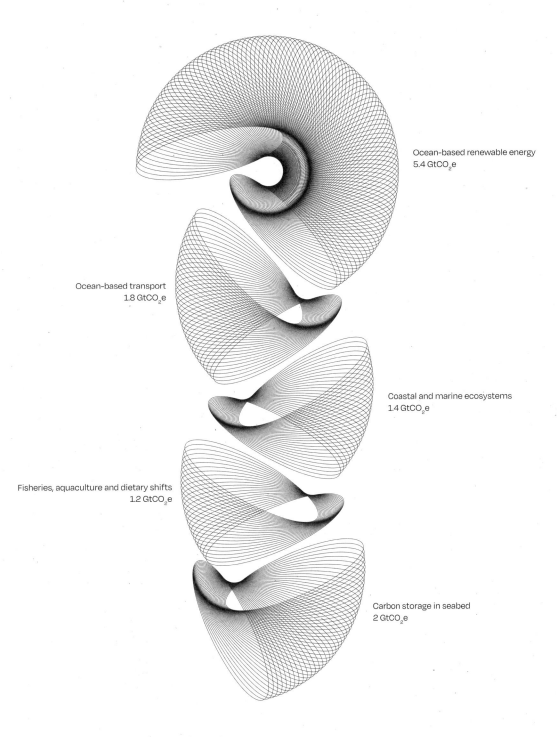

Ocean-based renewable energy
5.4 GtCO$_2$e

Ocean-based transport
1.8 GtCO$_2$e

Coastal and marine ecosystems
1.4 GtCO$_2$e

Fisheries, aquaculture and dietary shifts
1.2 GtCO$_2$e

Carbon storage in seabed
2 GtCO$_2$e

Components of Land Recycling per Country

The graph presents land recycling, broken down into its three components (densification, grey recycling and green recycling), as a percentage of total land consumption for the European Union Member States. The values show the average values of all functional urban areas per country.

The land recycling indicator comprises two concepts of urban development – land densification and land recycling. Land recycling is defined as the reuse of abandoned, vacant or underused land for redevelopment. It includes grey recycling and green recycling.

1) Land densification is defined as the land development that takes place within existing communities, making maximum use of the existing infrastructure instead of building on previously undeveloped land;

2) Grey recycling is when "grey" urban objects, such as buildings or transport infrastructures, are built under redevelopment;

3) Green recycling is when "green" urban objects, such as green urban areas or sport facilities, are built.

Source: Copernicus Land Monitoring Service – Urban Atlas (*Urban Atlas Change 2006-2012*), provided by European Environment Agency (EEA). Consulted July 2023.

Legend

Country

Each group is a country, the three branches and circles are the components of land recycling

- Densification
- Grey recycling
- Green recycling

2 1.5 1

Area of the circles and numbers = components of land recycling as a percentage of total land consumption (%)

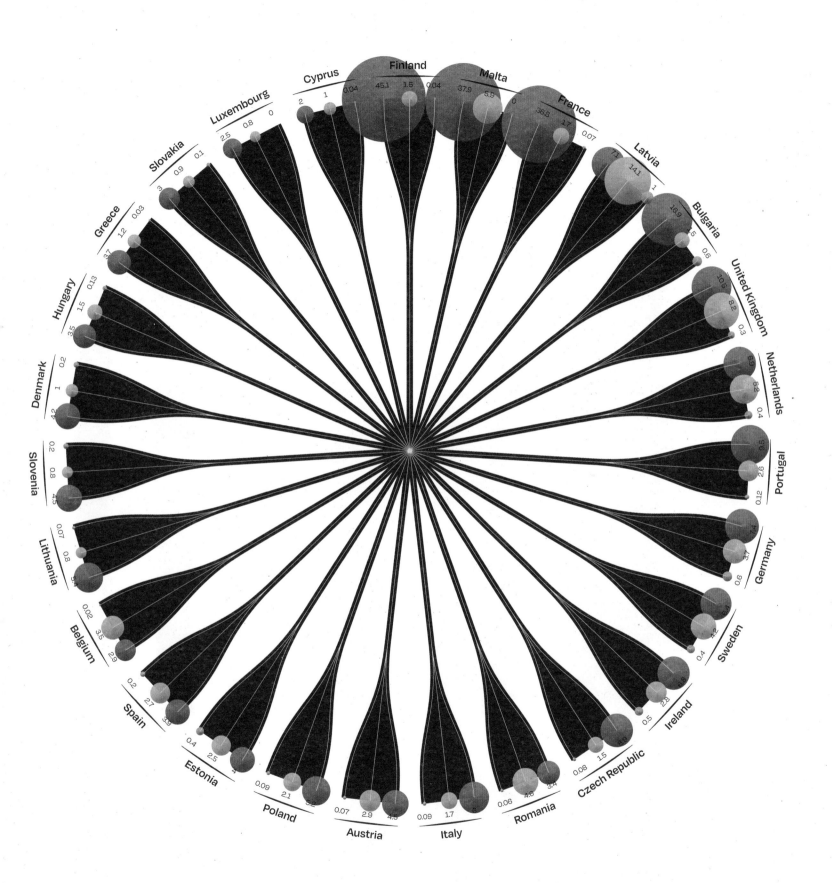

Share of Primary Energy from Renewable Sources in Europe from 1980 to 2021

The graphic shows share of primary energy consumption that came from renewable technologies in Europe from 1980 to 2021. The selected countries are the top 20 ones for share of primary energy from renewable sources in Europe in 2021. Renewable energy sources include hydropower, solar, wind, geothermal, bioenergy, wave, and tidal. They don't include traditional biofuels, which can be a key energy source, especially in lower-income settings.

Source: Our World in Data based on *BP Statistical Review of World Energy* (2022). Consulted July 2023.

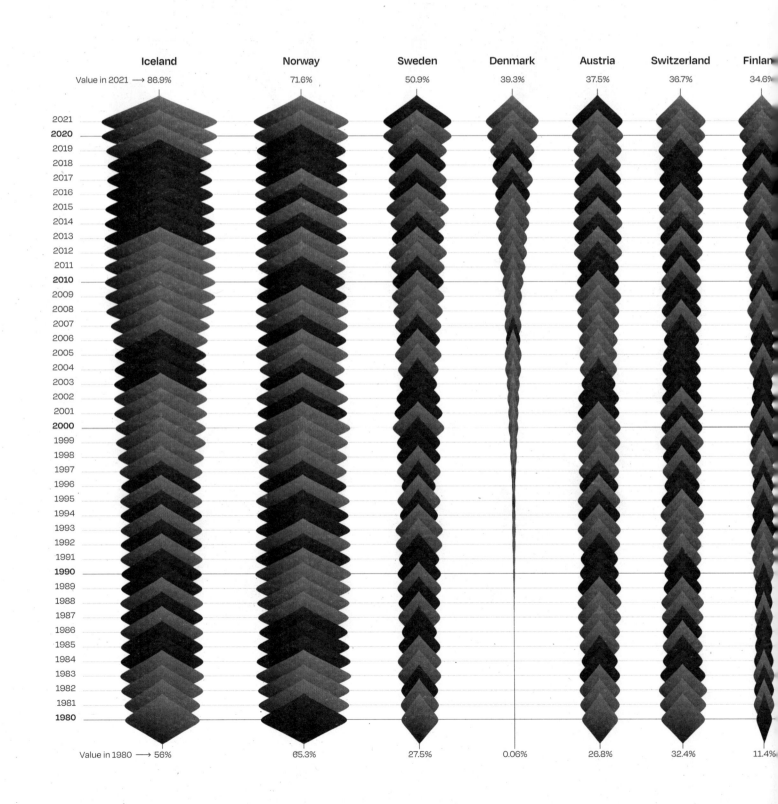

	Iceland	Norway	Sweden	Denmark	Austria	Switzerland	Finland
Value in 2021 →	86.9%	71.6%	50.9%	39.3%	37.5%	36.7%	34.6%
Value in 1980 →	56%	65.3%	27.5%	0.06%	26.8%	32.4%	11.4%

Each group of shapes is a country

Country

2021
2020
2019
2018

Each individual shape is a year

Width of the shape = share of primary energy from renewable sources by year

Colour = change over the previous year

The share has increased

The share has decreased

Change data not available

/ 1980 data not available

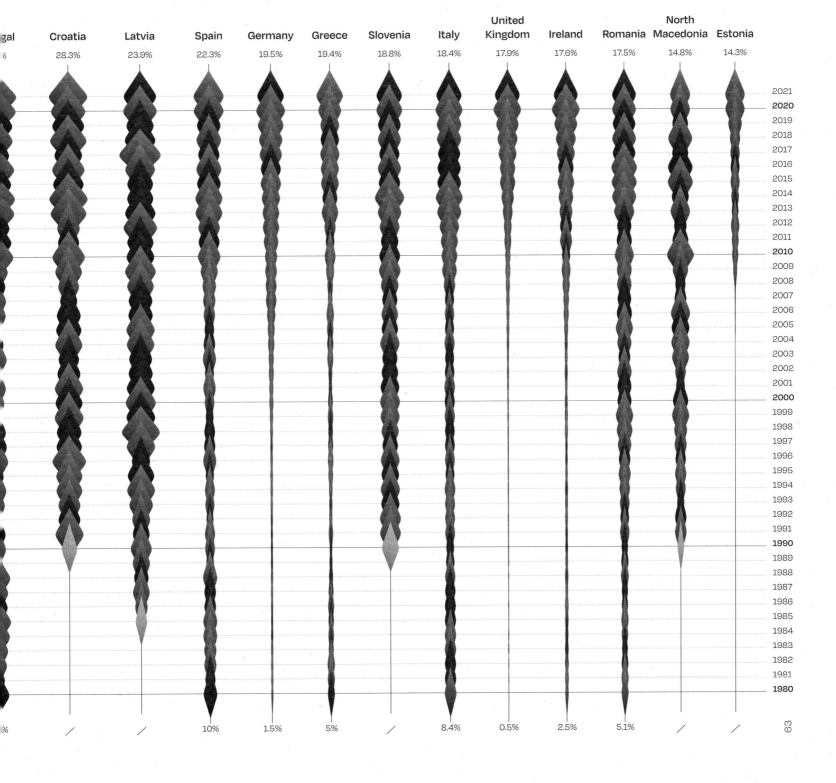

gal	Croatia	Latvia	Spain	Germany	Greece	Slovenia	Italy	United Kingdom	Ireland	Romania	North Macedonia	Estonia	
6	28.3%	23.9%	22.3%	19.5%	19.4%	18.8%	18.4%	17.9%	17.6%	17.5%	14.8%	14.3%	

													2021
													2020
													2019
													2018
													2017
													2016
													2015
													2014
													2013
													2012
													2011
													2010
													2009
													2008
													2007
													2006
													2005
													2004
													2003
													2002
													2001
													2000
													1999
													1998
													1997
													1996
													1995
													1994
													1993
													1992
													1991
													1990
													1989
													1988
													1987
													1986
													1985
													1984
													1983
													1982
													1981
													1980
%	/	/	10%	1.5%	5%	/	8.4%	0.5%	2.5%	5.1%	/	/	

Projections for Geothermal Heat Production in Europe

Statistics

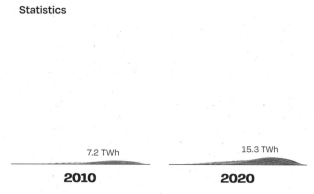

7.2 TWh

2010

15.3 TWh

2020

Projections

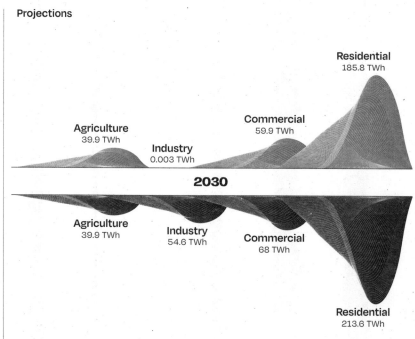

Agriculture
39.9 TWh

Industry
0.003 TWh

Commercial
59.9 TWh

Residential
185.8 TWh

2030

Agriculture
39.9 TWh

Industry
54.6 TWh

Commercial
68 TWh

Residential
213.6 TWh

* The figure shows long-term projections of the potential for applying geothermal energy as a source of heating services in various economic sectors, under two distinct scenarios: the *no-Paris projection* assumes a world in which little attention is given to the objectives of the Paris Agreement, while in the *Paris projection* all countries put in place strict climate control policy to keep global warming under 2 °C, which entails a net zero-emissions energy system in the European Union.

The presented data have been produced using the TIAM-ECN model, developed and operated at TNO, the Dutch institute for applied scientific research. TIAM-ECN is a tool that can simulate possible future developments of the energy system in various world regions, considering all energy supply and demand sectors, in specific scenarios.
The results of this model should be interpreted as potential realizations, rather than predictions, of the future energy system under a set of policy assumptions.

Source: F. Dalla Longa, L. Nogueira, J. Limberger, J.-D. van Wees and B. van der Zwaan, "Scenarios for geothermal energy deployment in Europe", *Energy* 206 (2020), with permission from the authors. Consulted July 2023.

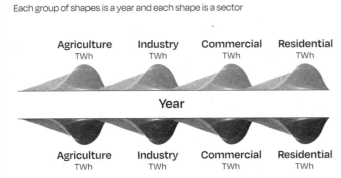

Each group of shapes is a year and each shape is a sector

Agriculture
TWh

Industry
TWh

Commercial
TWh

Residential
TWh

Year

Agriculture
TWh

Industry
TWh

Commercial
TWh

Residential
TWh

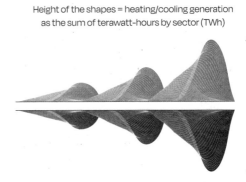

Height of the shapes = heating/cooling generation
as the sum of terawatt-hours by sector (TWh)

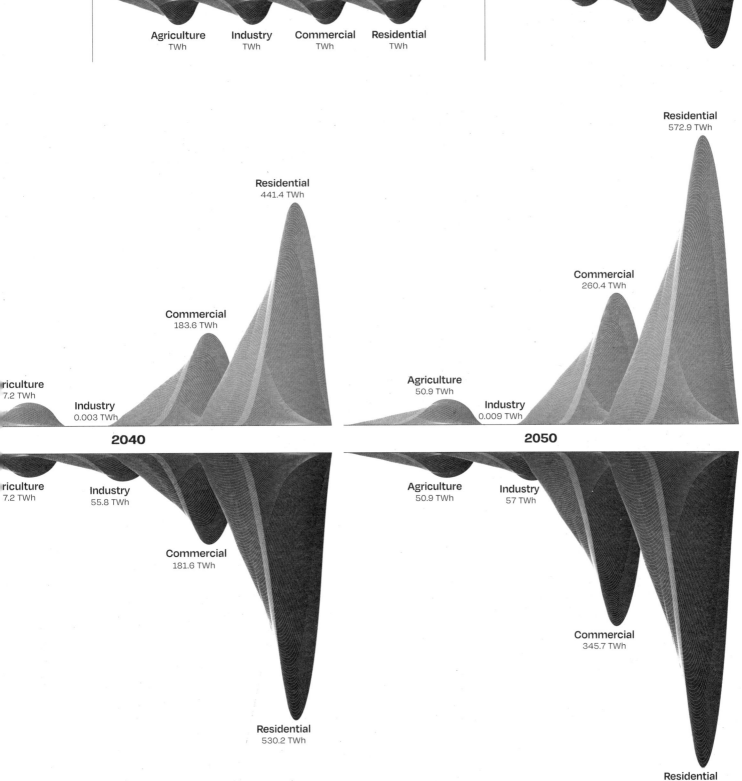

Residential
441.4 TWh

Commercial
183.6 TWh

riculture
7.2 TWh

Industry
0.003 TWh

2040

riculture
7.2 TWh

Industry
55.8 TWh

Commercial
181.6 TWh

Residential
530.2 TWh

Residential
572.9 TWh

Commercial
260.4 TWh

Agriculture
50.9 TWh

Industry
0.009 TWh

2050

Agriculture
50.9 TWh

Industry
57 TWh

Commercial
345.7 TWh

Residential
626.5 TWh

pp. 56–57

The construction of a circular future runs through a complex and multifaceted, yet fundamental, dynamic and necessary transition process. It stems from an understanding of the most basic and vital process that exists in nature, photosynthesis, and passes through the creation of integrated, fluid and co-dependent systems that allow natural systems to independently, and perpetually, regenerate themselves. Just as the new frontier of medicine passes through an understanding of the infinite potential of our immune system, the possibility of closing the circle for the survival of human life on planet Earth passes through an understanding of the importance of ecosystems, their preservation and, where possible, their empowerment. Of the human necessity to become an ecosystem.

pp. 58–59

Zero-emission circular economy emerges as the only solution to avoid the worst-case scenario of the climate crisis for the future.
By switching from a linear to a circular mentality, waste can be reduced, resources conserved and environmental impacts minimised.
While the transition to renewable energy and energy efficiency measures can address 55% of global emissions, circular economy strategies are needed to tackle the remaining 45%. Combining energy efficiency with food production is a critical aspect of these strategies. The key here is water, particularly the health of our seas and oceans. Marine activities have enormous potential to mitigate greenhouse gas emissions, and how we harness and safeguard these activities is clearly of the utmost importance – often on a scale that defies our understanding.

pp. 60–61

A key factor in the development of circular models is the relationship between man and machine, between intellect and industrial production. Just as technology can make a difference in the creation of optimised processes in the preservation and recovery of raw materials, intellect and the ability to think outside the box are what trigger processes of change and turn problems into opportunities. The processes of brownfield recovery and regeneration, and the recovery of raw materials (textiles, metals, plastics) are a great demonstration of this. Brownfield recovery and regeneration represent a valuable opportunity, not only to prevent the disappearance of unspoilt natural areas but also to develop urban spaces and reclaim sometimes contaminated land: land is a limited resource too. Abandoned industrial areas, often considered a problem, can be valuable for both sustainable development and urban renewal. Transforming disused areas into vibrant spaces offers a multitude of benefits. Every year in the EU more than 1,000 km^2 of undeveloped land is used for housing, roads, industry and recreation, without taking full account of the various tangible and intangible services and values that this land provides. The European Environment Agency (EEA) has estimated that there are as many as three million brownfield sites across Europe, often located and well connected within urban boundaries, offering a competitive alternative to green investments.

pp. 62–63, 64–65

There is a place in Europe which represents the closing of the circle, the example of an efficient and powerful synergy between man and nature: Iceland, a land of volcanoes and the quintessence of the force of nature. Rich in hydroelectric and geothermal resources, Iceland

generates 100% of its electricity from clean energy, for both private and industrial consumption. Iceland has turned its geological specificity into a major strength, realising early on that geothermal energy offers enormous potential for solving a large part of the world's energy needs. One might be surprised, however, to note that the world's first geothermal power plant was built in 1911 in Larderello, Tuscany. Today, Larderello is home to Europe's largest geothermal power plant: the Valle Secolo plant, which has an installed power of 120 MW. More generally, Italy would have resources to produce up to 116,000 terawatt-hours of geothermal energy, against an annual requirement of just over 300. The exploitation of geothermal energy in Tuscany has historically been the subject of intense debate between the energy industry, experts and local populations regarding the actual sustainability through current exploitation processes, and the social and landscape-related consequences.

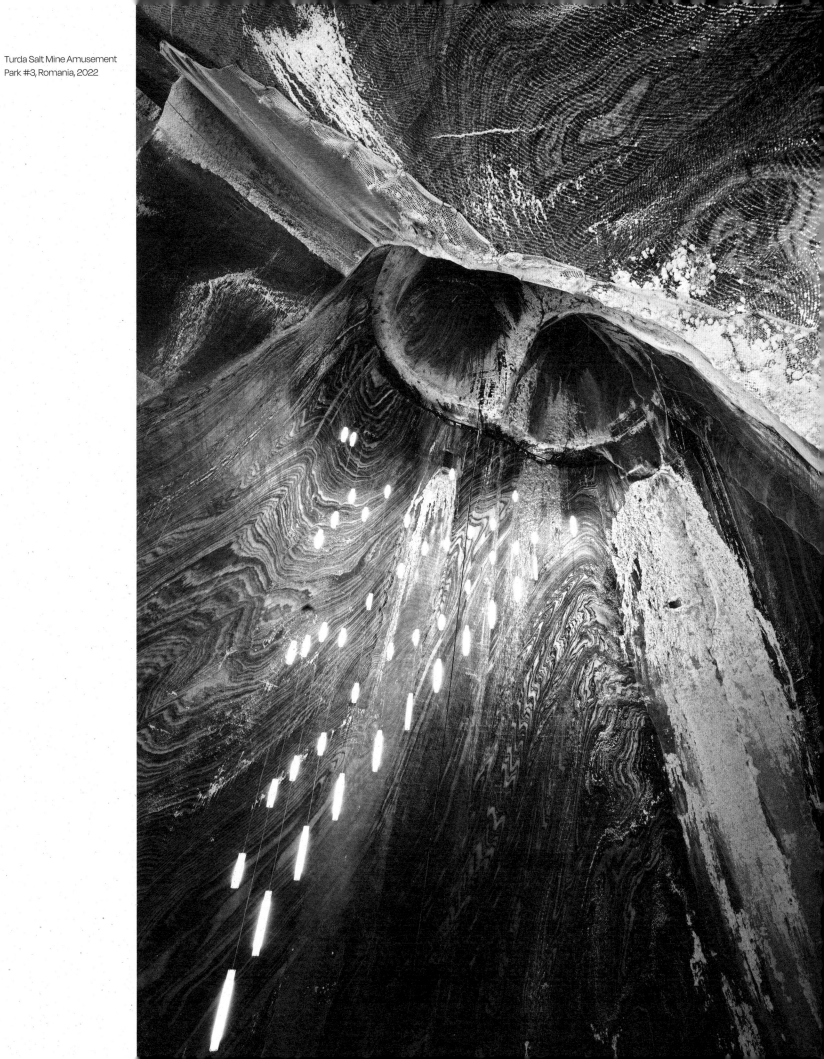

Turda Salt Mine Amusement
Park #3, Romania, 2022

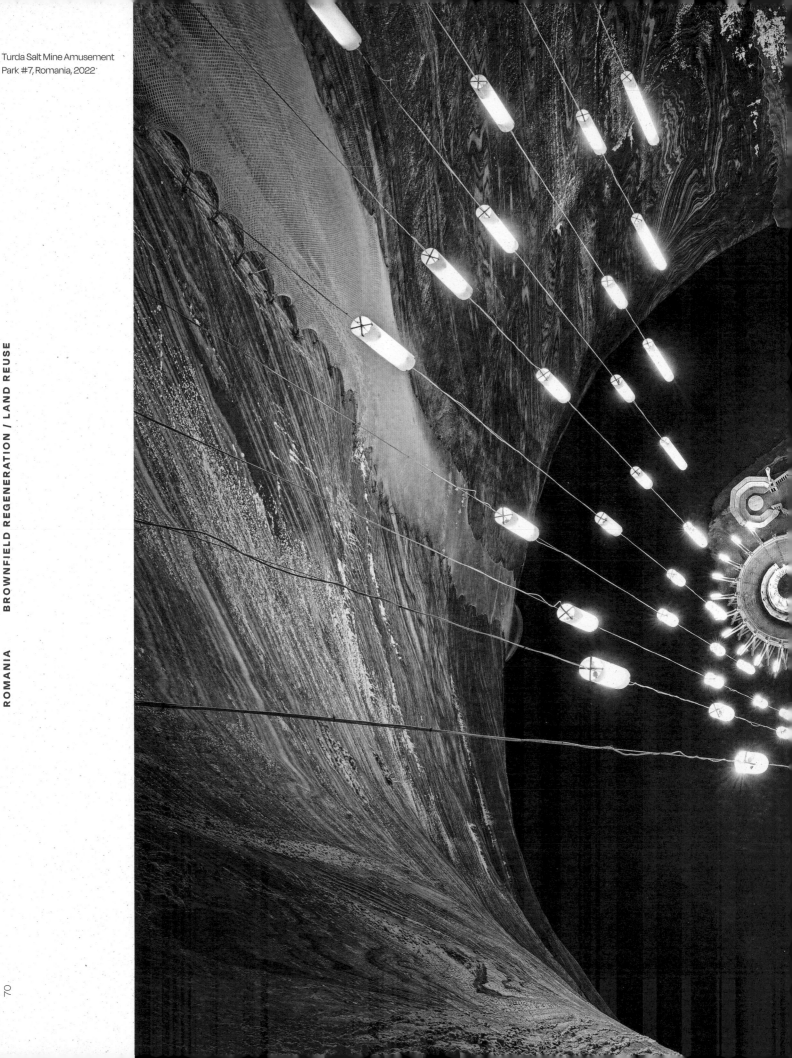

ROMANIA BROWNFIELD REGENERATION / LAND REUSE

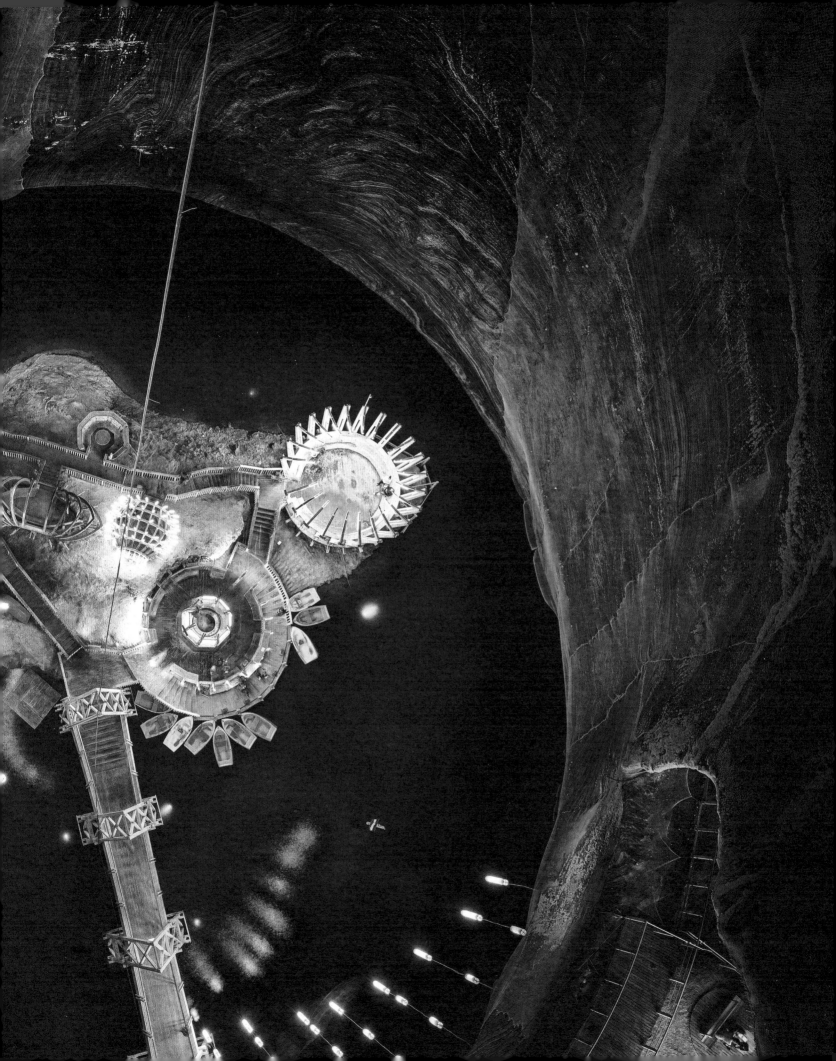

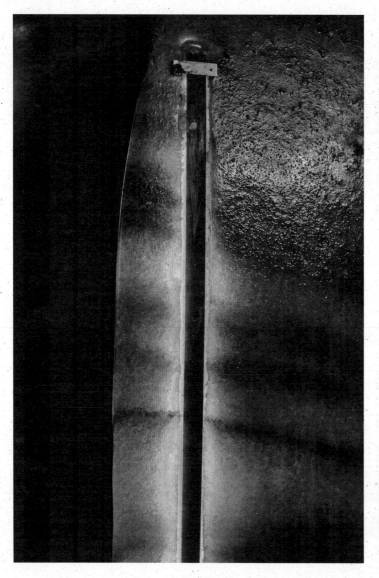

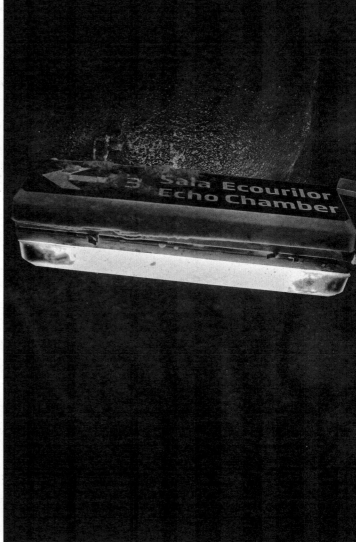

Turda Salt Mine Amusement
Park #5, Romania, 2022

Turda Salt Mine Amusement
Park #4, Romania, 2022

Turda Salt Mine Amusement
Park #2, Romania, 2022

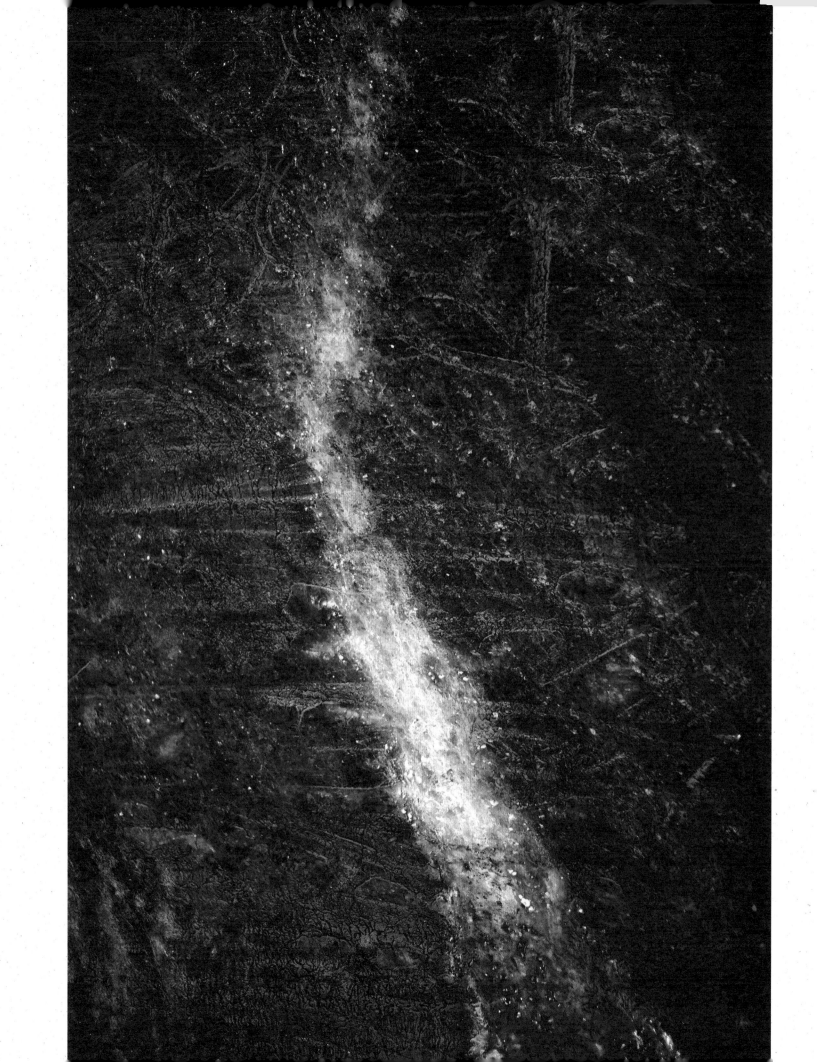

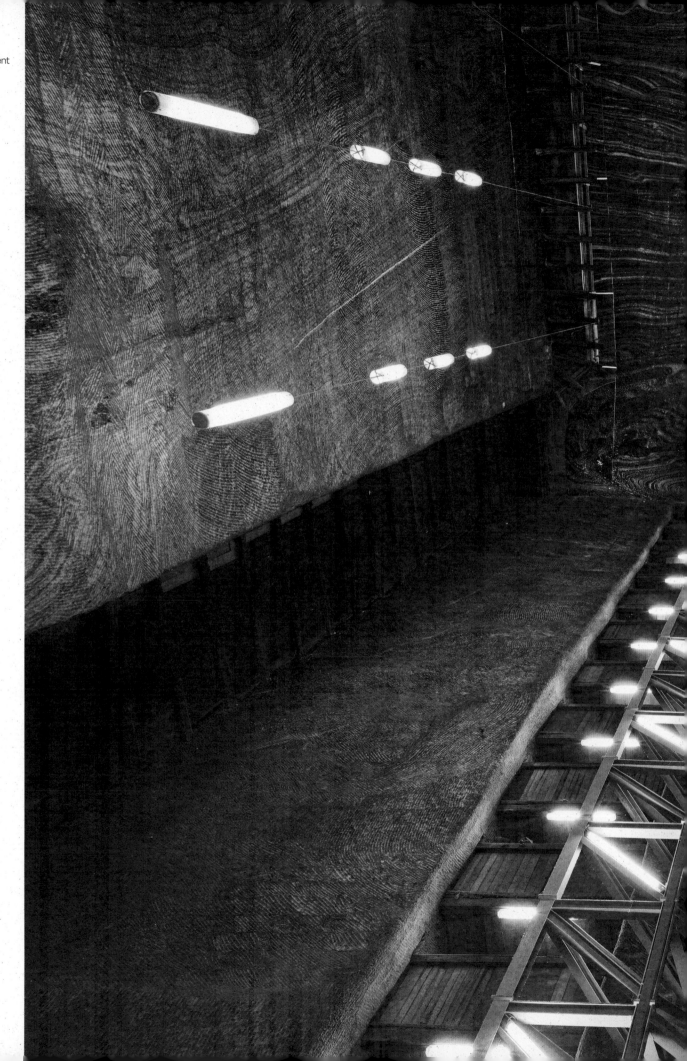

ROMANIA BROWNFIELD REGENERATION / LAND REUSE

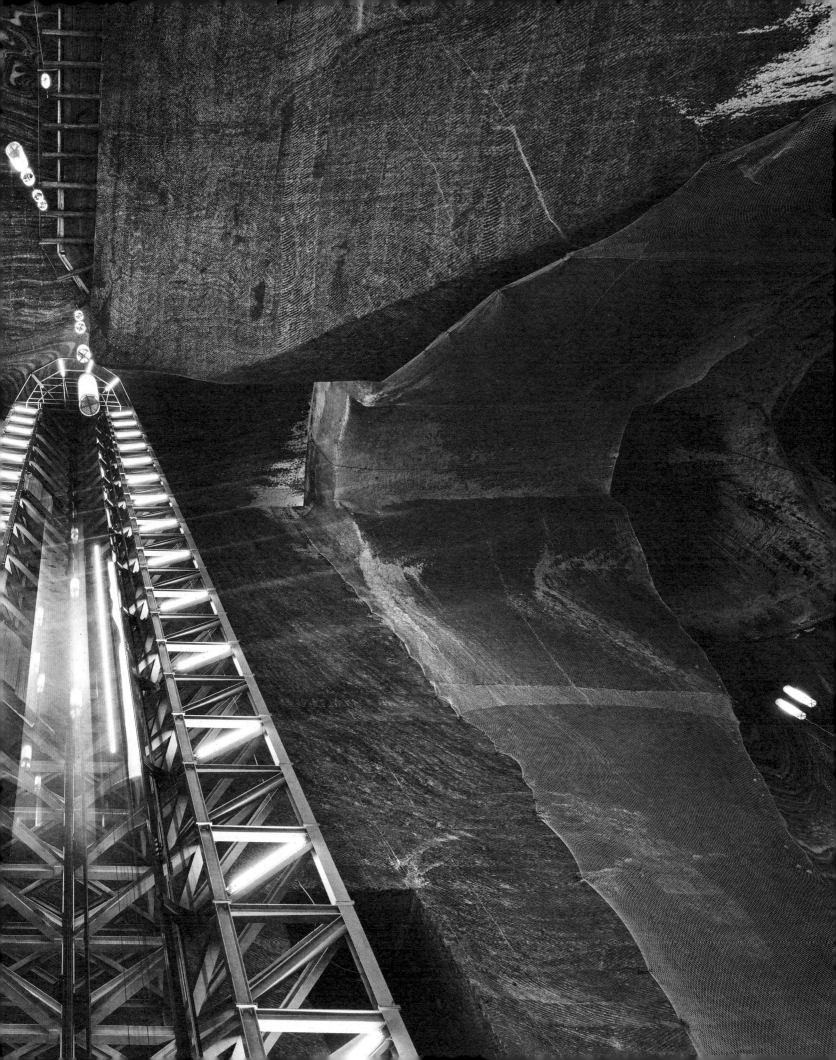

Turda Salt Mine Amusement
Park #6, Romania, 2022

Turda Salt Mine Amusement
Park #8, Romania, 2022

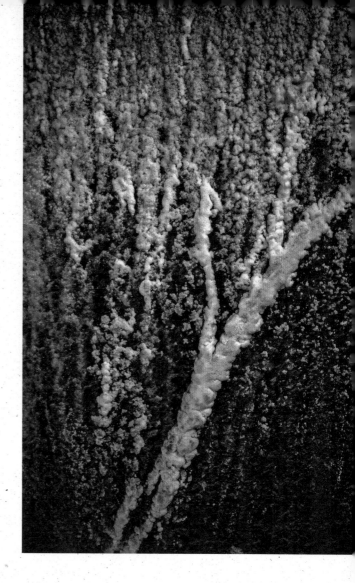

Historically among the most important in Transylvania, the Turda salt
mine was the main source of salt supply in the area.
During their occupation of Dacia, when the city was known by its Latin
name Potaissa, the Romans exploited it for iron, silver and gold, but there
is no clear evidence of salt mining. Therefore, historians date the
beginning of this activity to around the 11th–13th century. The decline of
the mine began in 1840: social and economic conditions caused mining
to be relocated to other parts of the state, leading to its total closure in
1932. From 2008 to 2010, the mine was extensively modernised and
improved, respecting the need to preserve the natural elements and the
old mining tools. Today it is open to tourists and offers various
attractions, such as a big wheel, a minigolf course, table tennis, billiards
and rowing boats on an underground lake.
The mine covers an area of about 45 km^2, with an average salt thickness
of about 400 metres, and consists of several chambers.
It attracts 680,000 visitors a year who can access it via a huge lift and
wooden stairs located in the Rudolf Mine. Light is provided by lanterns
hanging from the ceiling that reach the ground. The lowest point is at a
depth of 120 metres and, there, people can go rowing on the
underground lake in the Theresa Mine.

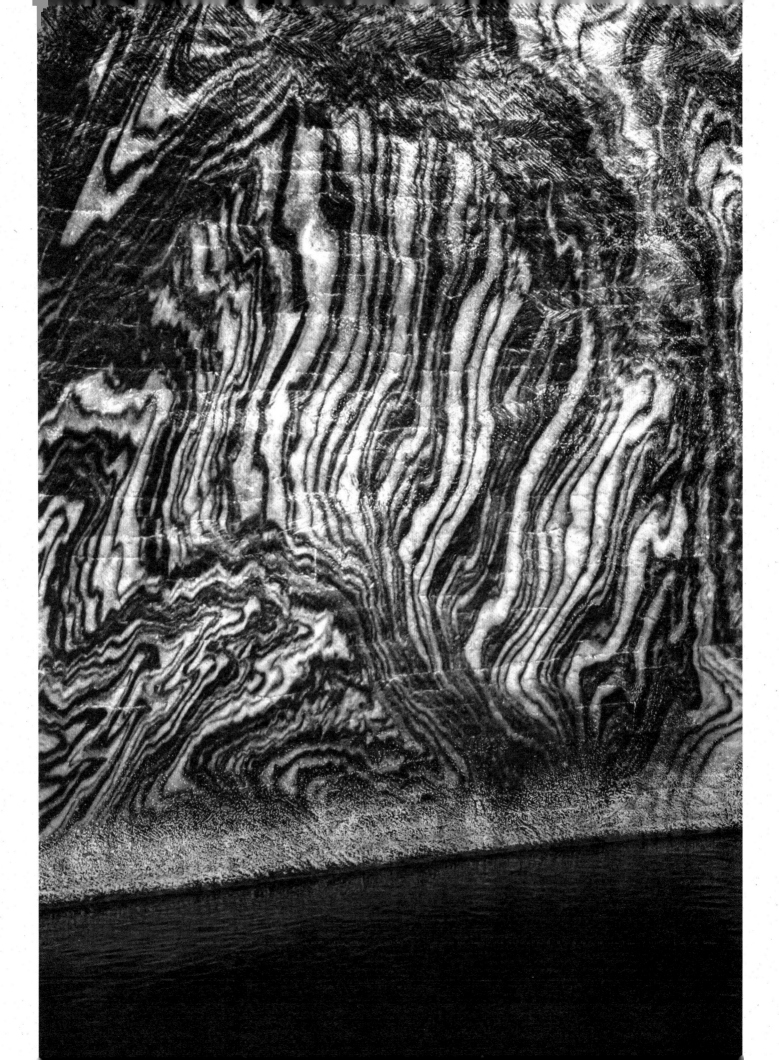

NORWAY BROWNFIELD REGENERATION / LAND REUSE

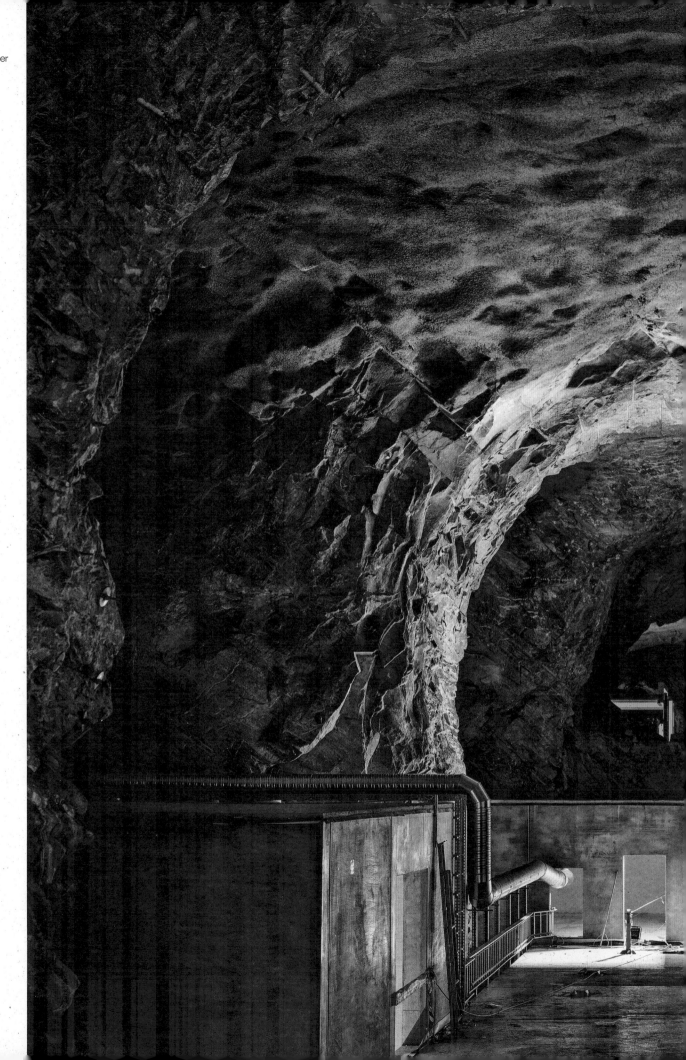

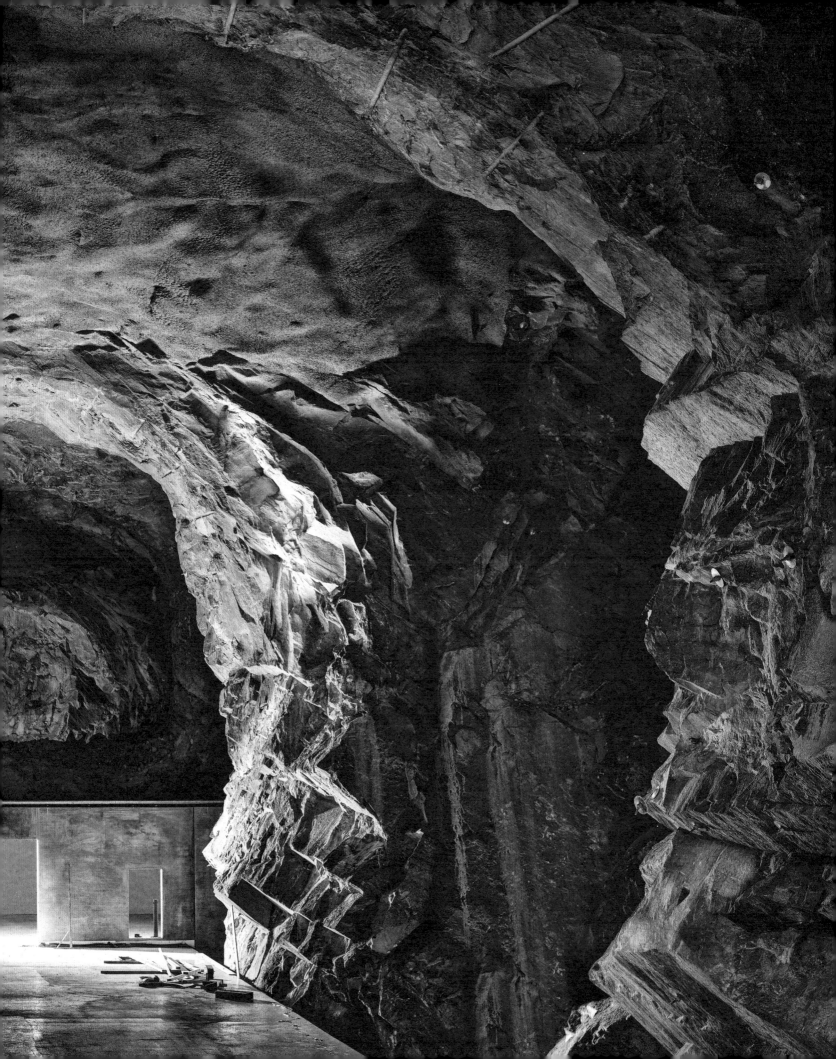

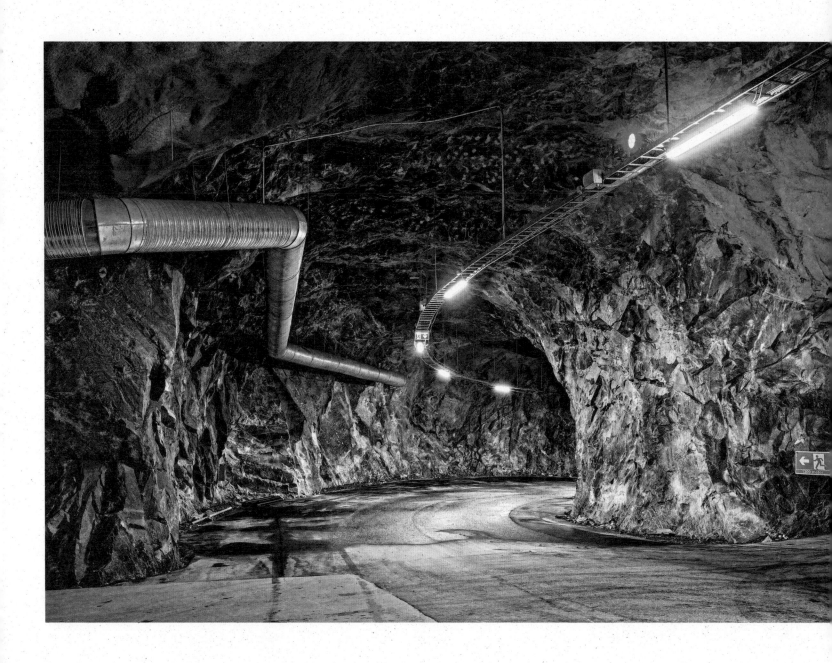

Circular Datacenter - Former
Mine #5, Norway, 2022

Circular Datacenter - Former
Mine #6, Norway, 2022

Circular Datacenter - Former
Mine #4, Norway, 2022

Circular Datacenter - Former
Mine #2, Norway, 2022

Circular Datacenter - Former
Mine #1, Norway, 2022

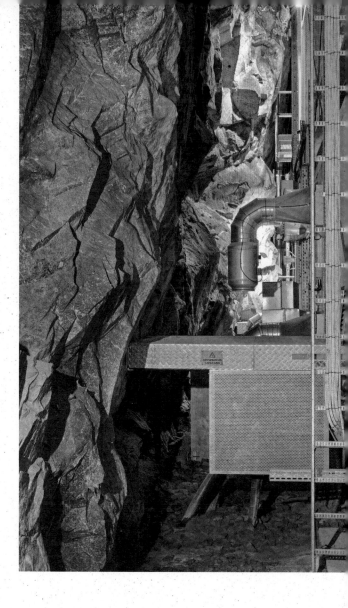

Located within a former olivine mine on the west coast of Norway, this datacenter runs entirely on renewable energy. With zero CO_2 emissions and a limited ecological footprint, the facility achieves a PUE (Power Usage Effectiveness) of less than 1.15. The main part of the facility is not visible from the surrounding environment, giving it added protection. No evaporative cooling systems are required and the WUE (Water Usage Effectiveness) is zero: the datacenter utilises the cold fjord adjacent to the facility. Cold sea water interacts with heat exchangers and a closed fresh water circuit provides chilled water (with 2N redundancy) beneath the raised floor. In-line cooling is used to transform cold water into cold air, allowing a density of up to 50 kilowatts per rack (air cooling). With direct liquid cooling, the available density is up to 100 kilowatts per rack. The datacenter has the capacity to build 120,000 m² of white space in the facility and accommodate up to 200 megawatts of capacity. Thanks to the modular design, the time-to-market starts from 6–8 weeks.

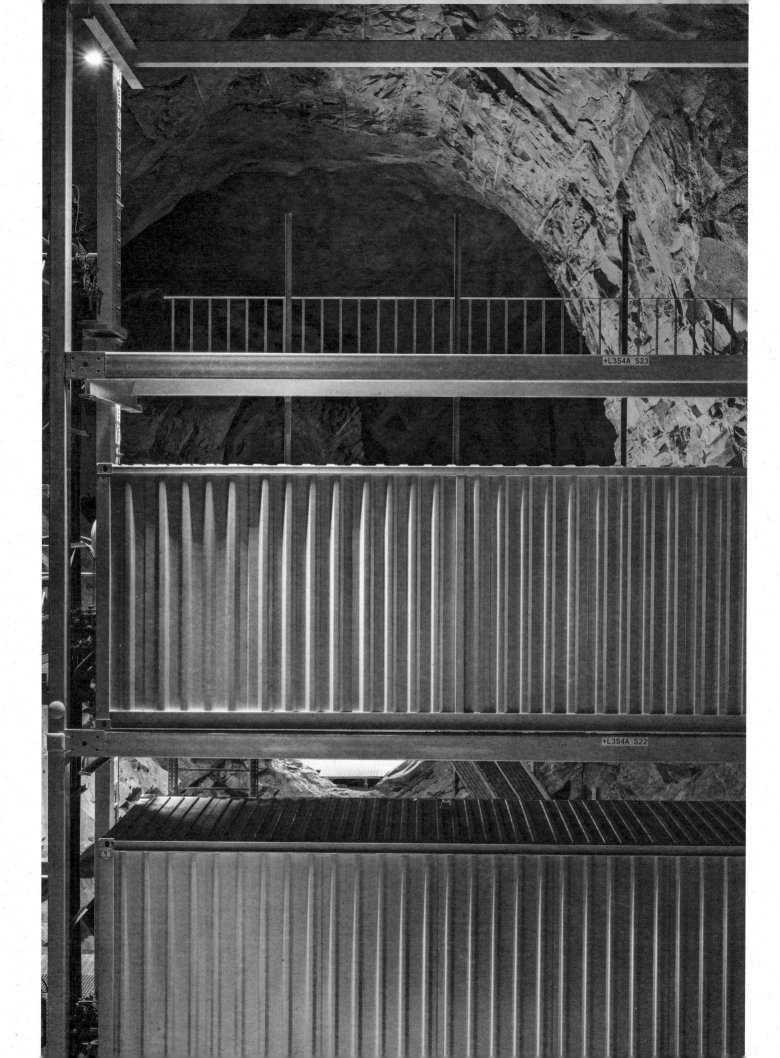

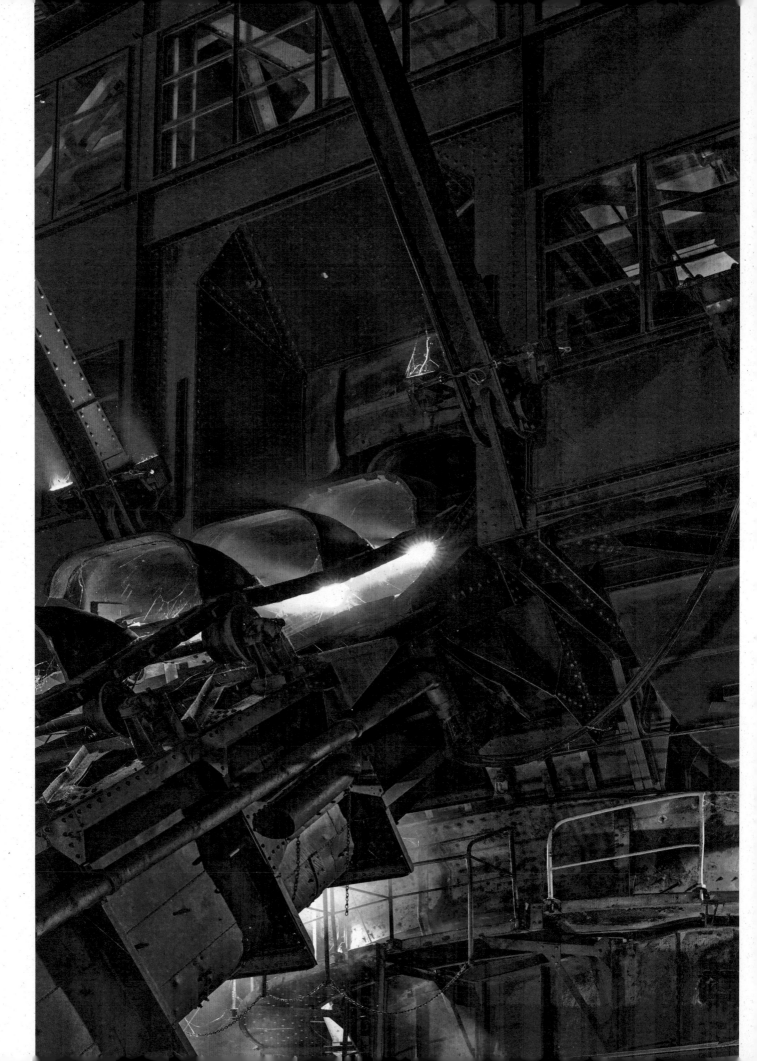

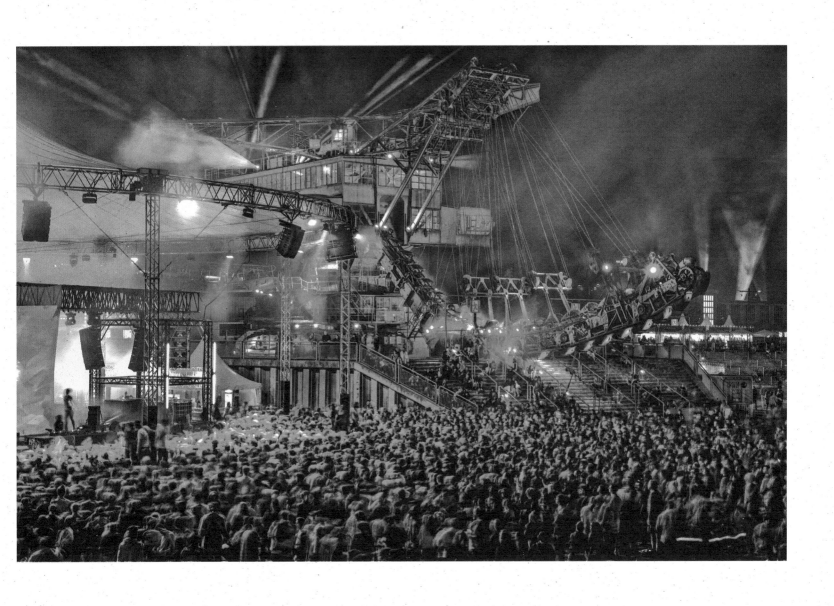

Coal Mine Future
Ferropolis #6,
Germany, 2022

Coal Mine Future
Ferropolis #3,
Germany, 2022

GERMANY · BROWNFIELD REGENERATION / LAND REUSE

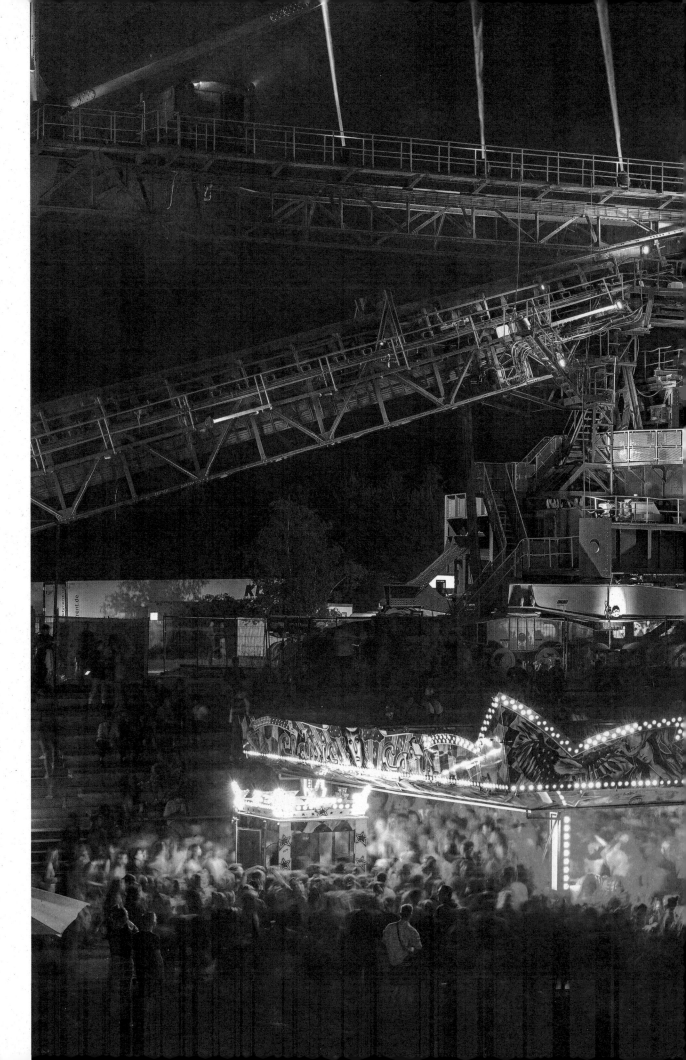

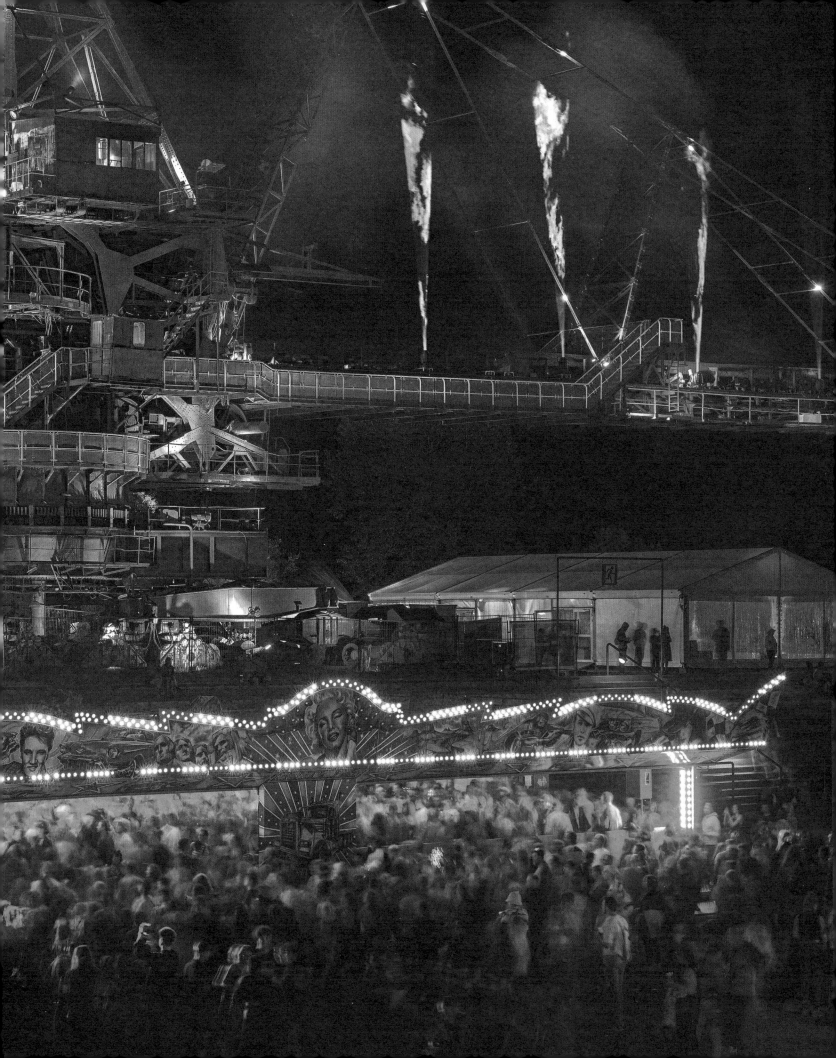

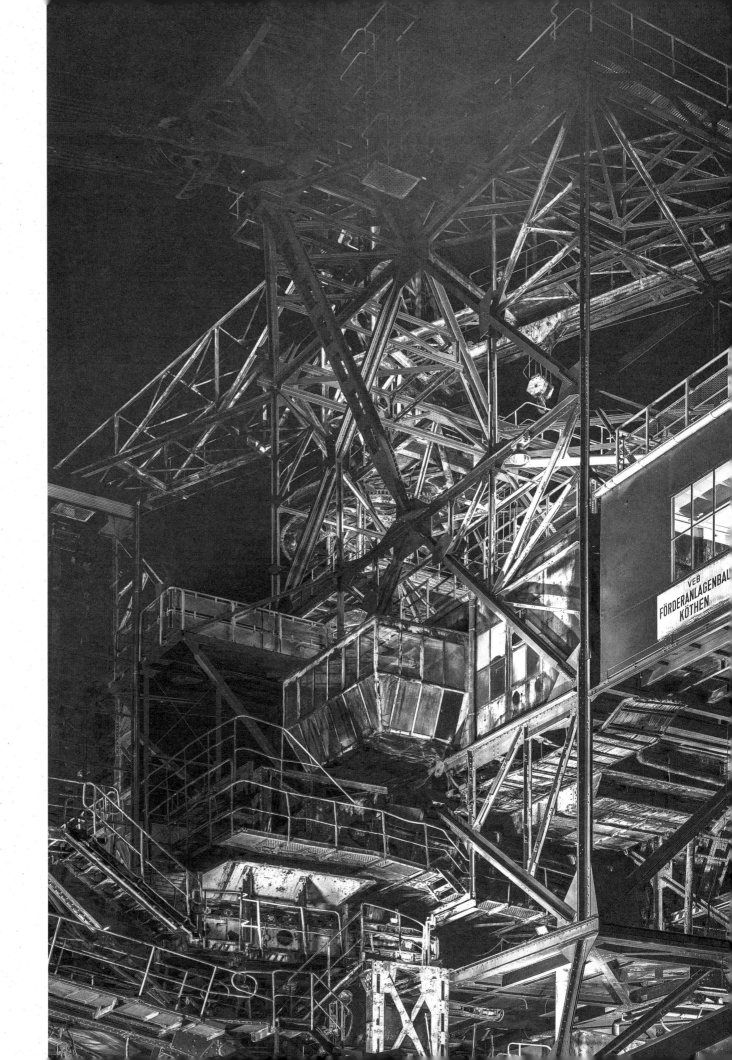

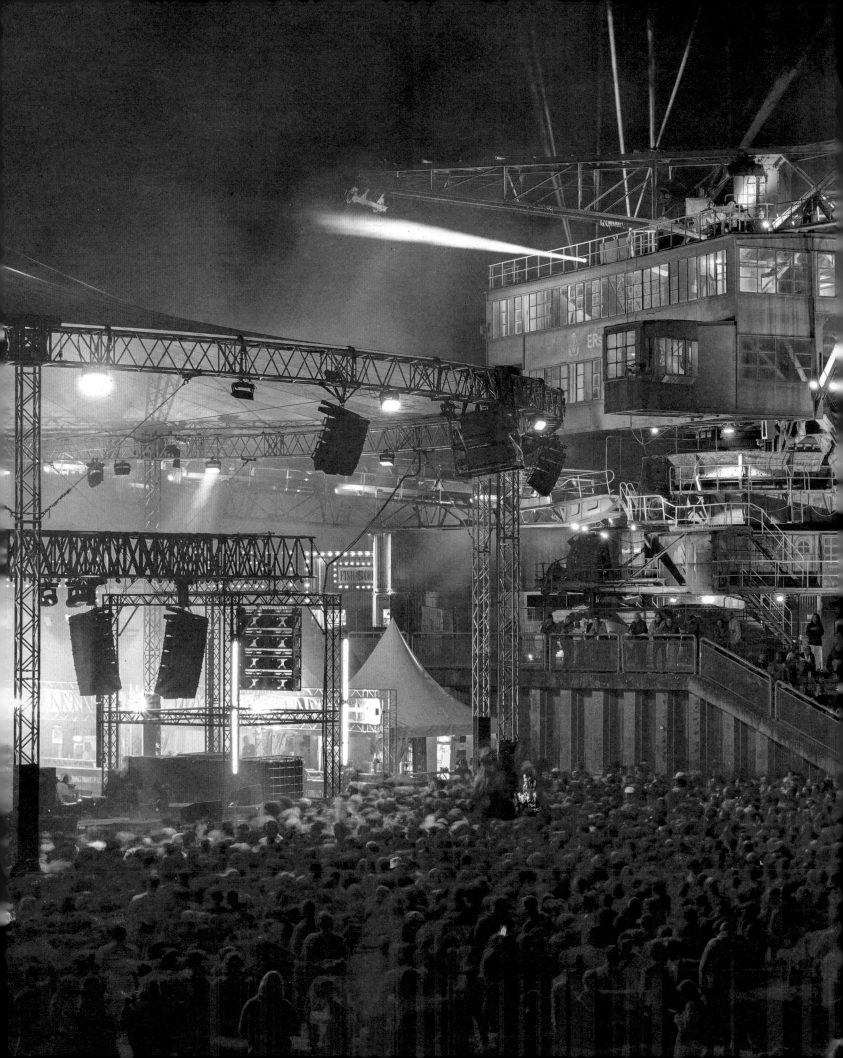

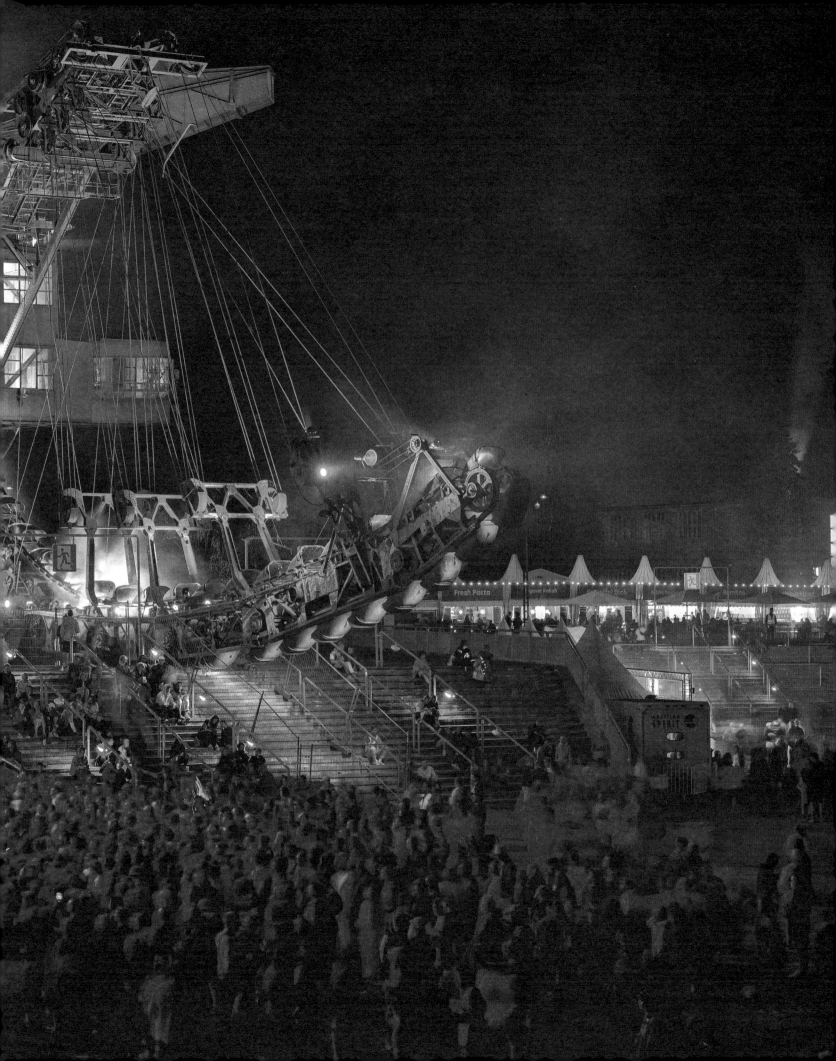

Located in Gräfenhainichen, between Wittenberg and Dessau, Germany, this former open-cast coal mine has been transformed into a museum of huge industrial machines dating to the mid-20th century. Some of these machines are up to 30 metres high and 120 metres long, and weigh up to 1980 tonnes. The site is a stop on the European Industrial Heritage Trail (ERIH).

Today, the complex houses a museum, an industrial monument, a steel sculpture, an event venue and a theme park. Its strict waste disposal policy obliges event organisers to follow the principle of the Recycling and Waste Management Act as closely as possible. The site is part of the New European Bauhaus.

A solar system has been installed on the roofs of the buildings. A total of 2,901 m^2 is covered by solar panels from QCells, which produce around 170,000 kilowatts of electricity per year and can cover the needs of around 50 households. Events held at the facility include Germany's largest outdoor electronic music festival, which consumes 73,000 kilowatts of electricity in a single weekend. Thanks to the installation of the solar roof, the festival can be powered entirely by renewable energy, which is fed into the national grid during the rest of the year.

Coal Mine Future
Ferropolis #7,
Germany, 2022

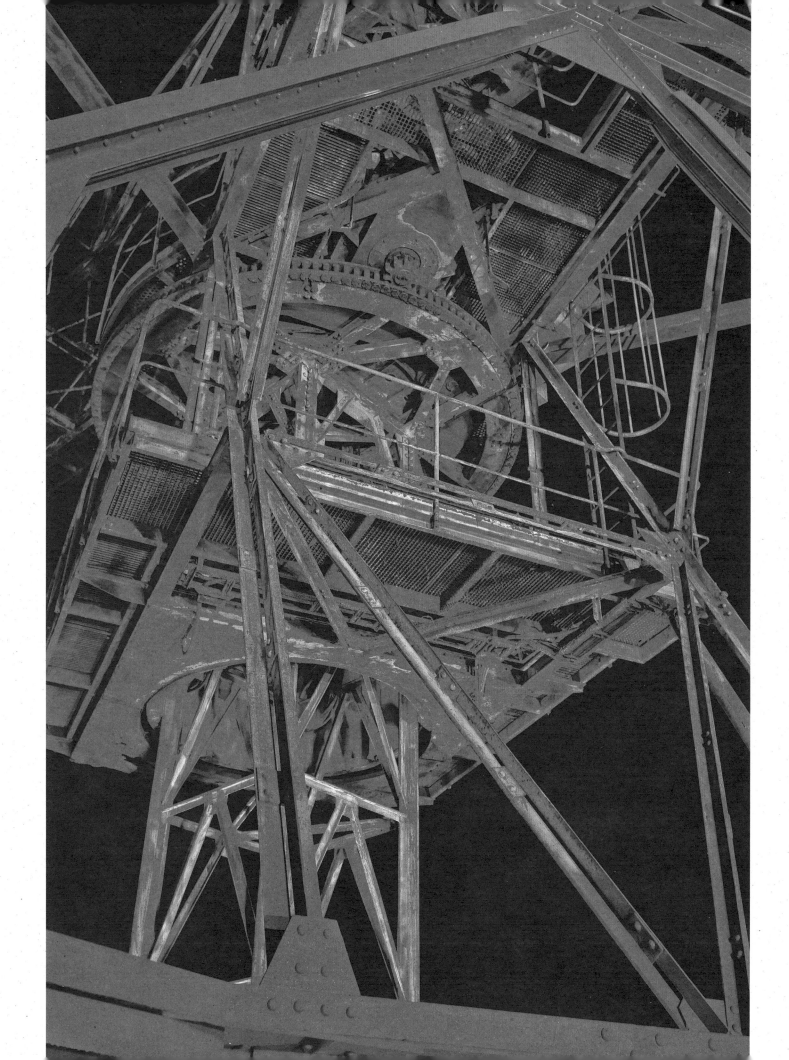

GERMANY TEXTILE RECYCLING

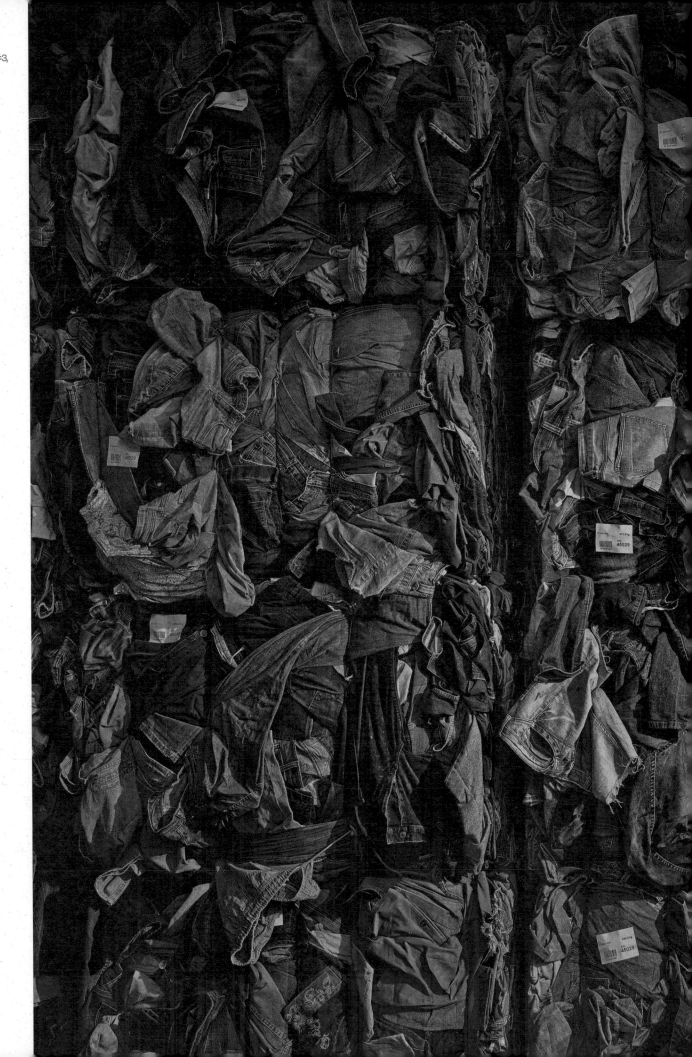

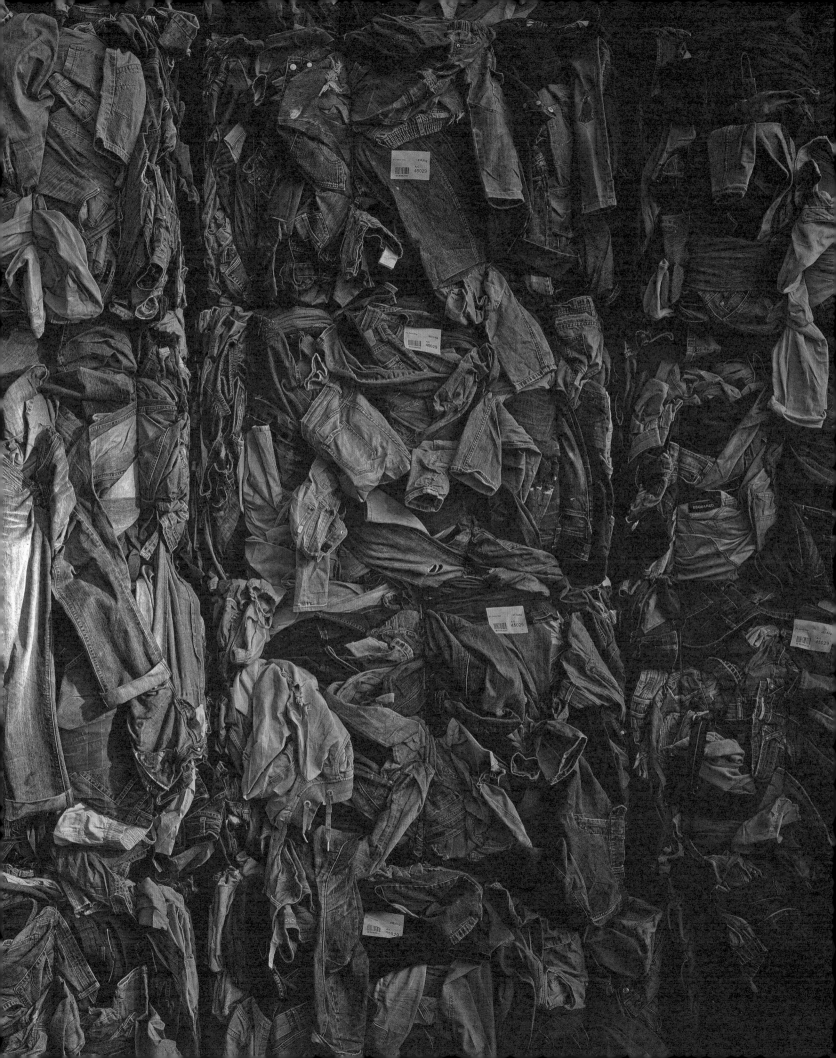

GERMANY TEXTILE RECYCLING

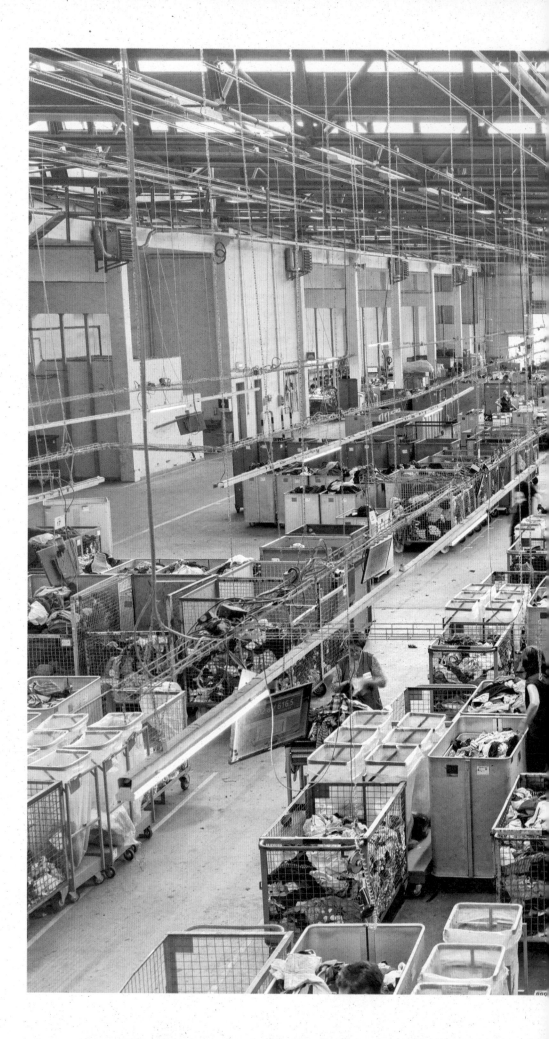

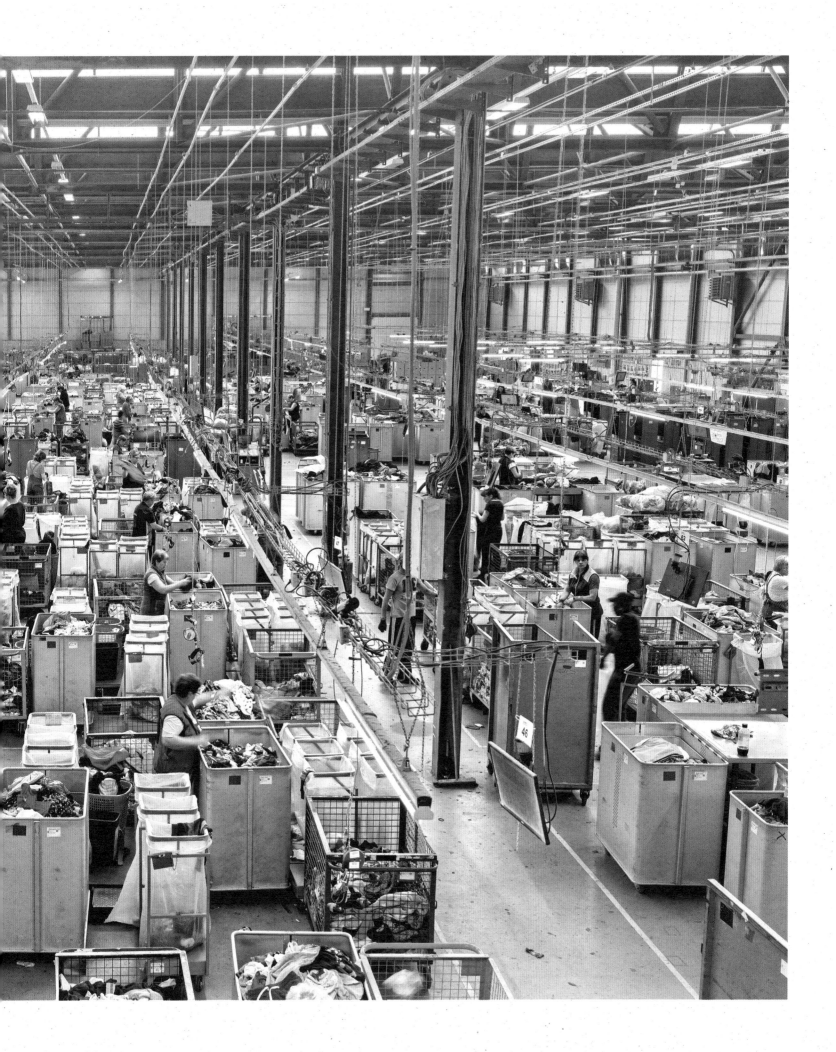

This German company specialises in sorting textile waste. One of the world's largest outfits in this sector, it has been recycling used textiles since 1999. Following the international waste hierarchy, which favours reuse over recycling, garments and shoes are inspected by hand, in order to give them a second life. Experts inspect used fabrics in several phases in line with 400 different criteria: each garment is sorted by hand and classified on the basis of its next use.

On an area the size of 13 football pitches, the 750 employees of the Bitterfeld-Wolfen plant sort up to 200 tonnes of used textiles and shoes every day, for an annual collection volume of 100,000 tonnes.

The company also uses an automated system that processes 2,500 tonnes of textiles per year and aims to solve the fibre-to-fibre recycling problem. The mechanical recycling plant processes unwearable used clothing, damaged articles and textile waste.

An artificial intelligence recognises individual garments and can sort them according to material or colour. Thanks to this technology, garments can be recycled and made into yarn. The artificial intelligence detects 78 materials and material combinations with an accuracy in measurement of more than 95%.

Every year 11,000 tonnes of used textiles are mechanically shredded in a plant operating 24/7 to create a recycled material mix.

Circular Fashion Recycle #5,
Germany, 2022

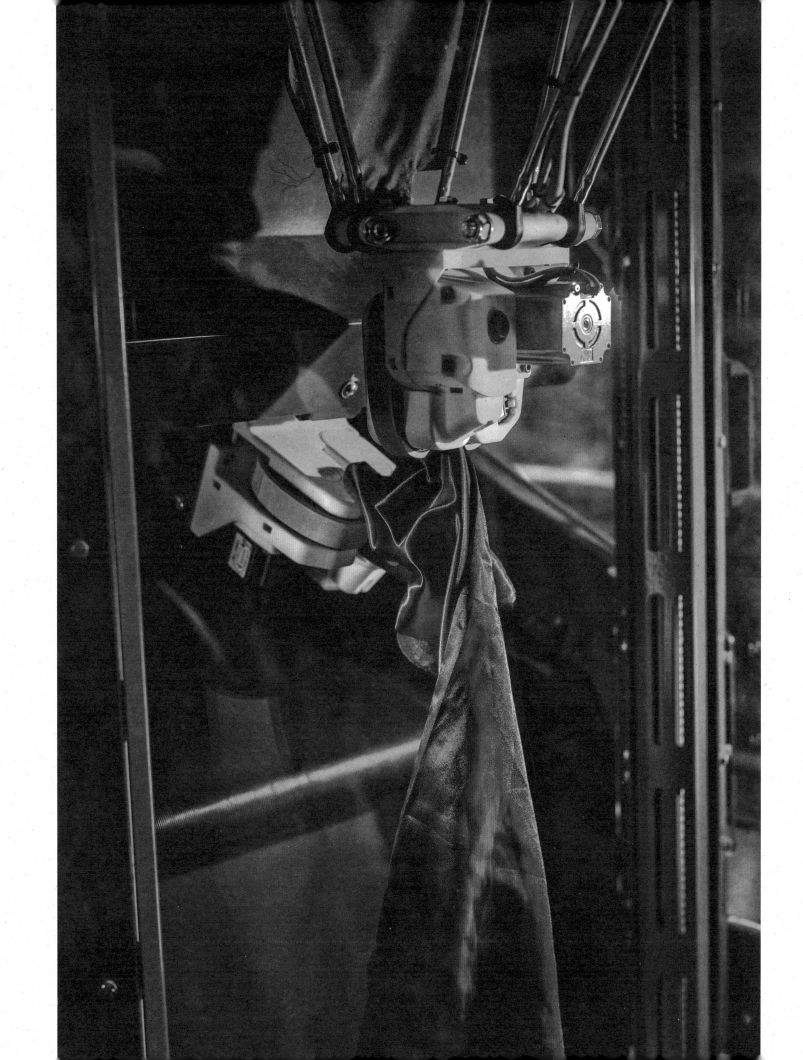

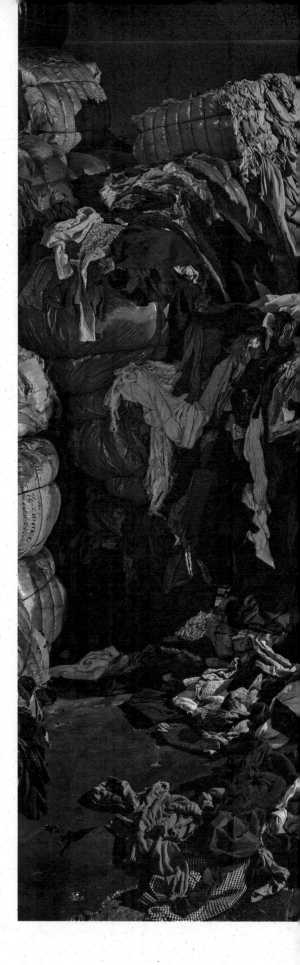

Circular Fashion Recycle #2,
Italy, 2019

Among the fabrics that are sorted, wool is the most common and popular recycled one. In Prato, the wool recycling industry has a long tradition. An early 20th-century law prohibiting the import of raw wool prompted the creation of a district in this small Tuscan town where today dozens of companies sort and recycle more than 15% of the world's textiles, with a market value of USD 2.5 billion. Although this has been going on for almost two centuries, it is only in recent years that these entrepreneurs have been able to start declaring the recycled nature of their wool. What was once considered a waste item is now a valuable fabric.

The wool available is greasy wool, a low-quality fibre that is dirty and coarse, resulting from the shearing of 7 million Italian sheep. It is a rough material, unattractive for the textile and clothing market, especially when compared to the extremely fine fibres from Australia and Argentina. More than 5,000 tonnes of fibre can be obtained from these almost 9,000 tonnes of discarded wool (12,000 tonnes according to other estimates). Something like 15 million square metres of fabric can be manufactured by re-using them, creating a sustainable, circular supply chain. Recent experiments have also shown that it is possible to improve the characteristics of Italian wool and make it softer.

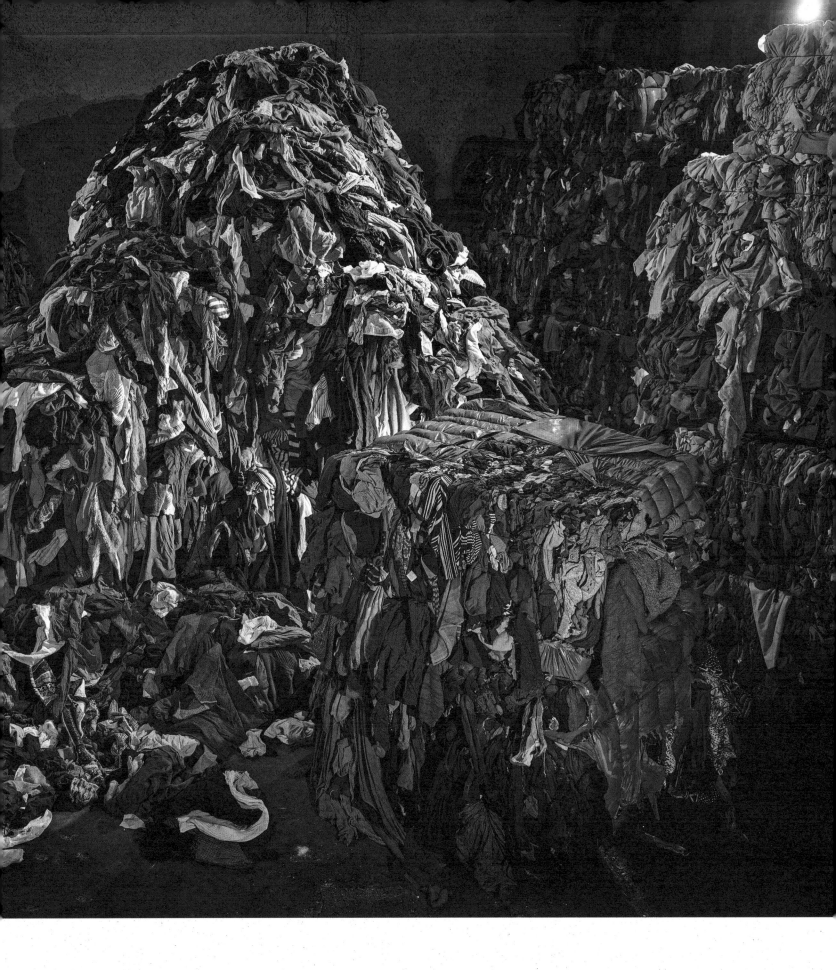

SLOVENIA NYLON RECYCLING

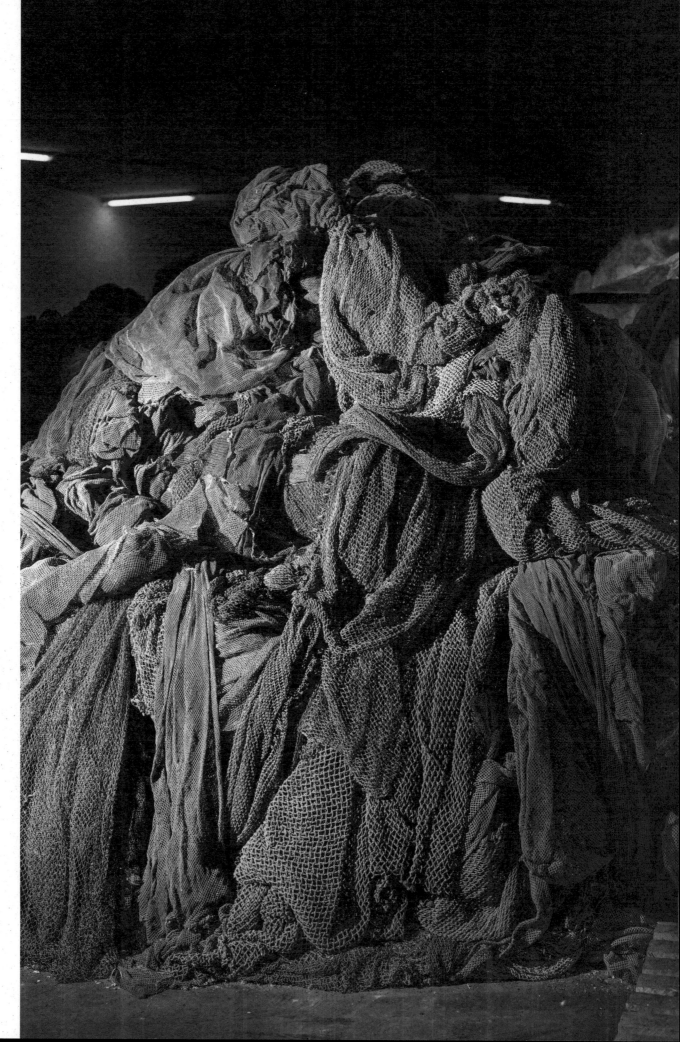

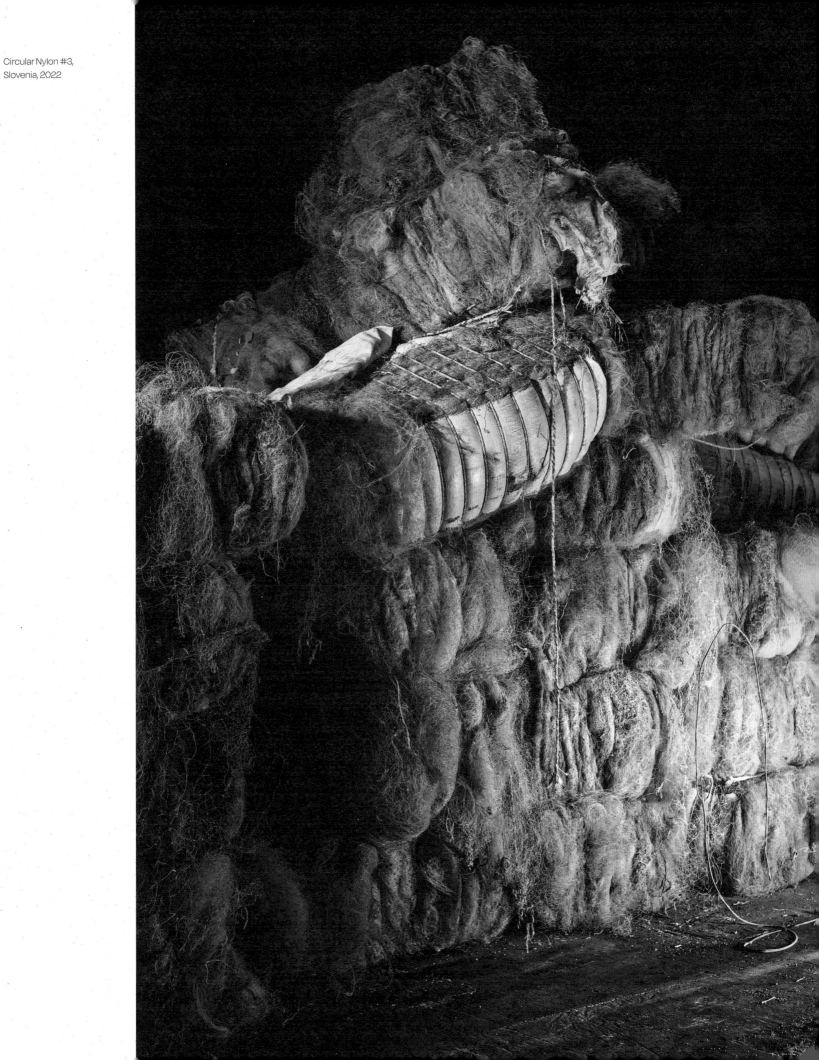

Circular Nylon #3,
Slovenia, 2022

SLOVENIA NYLON RECYCLING

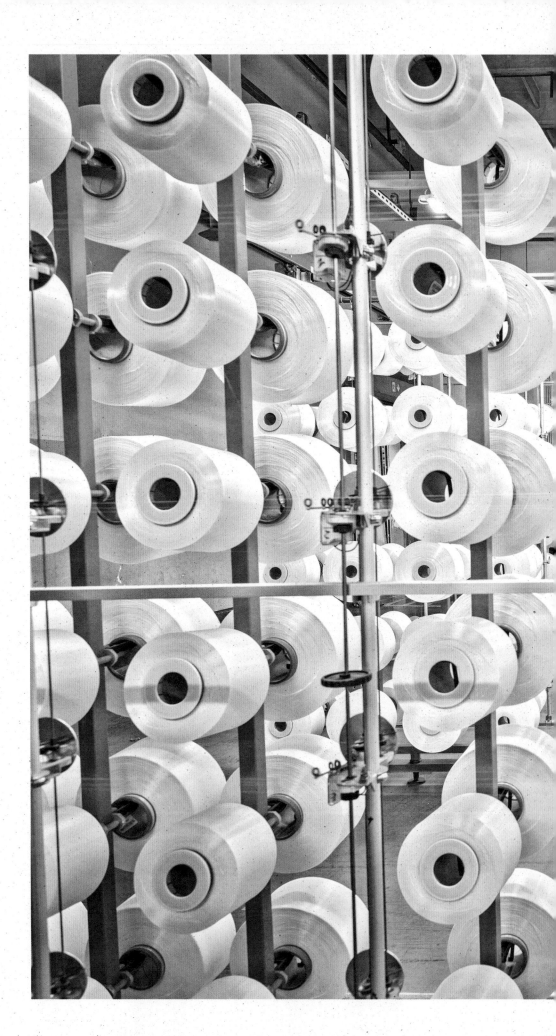

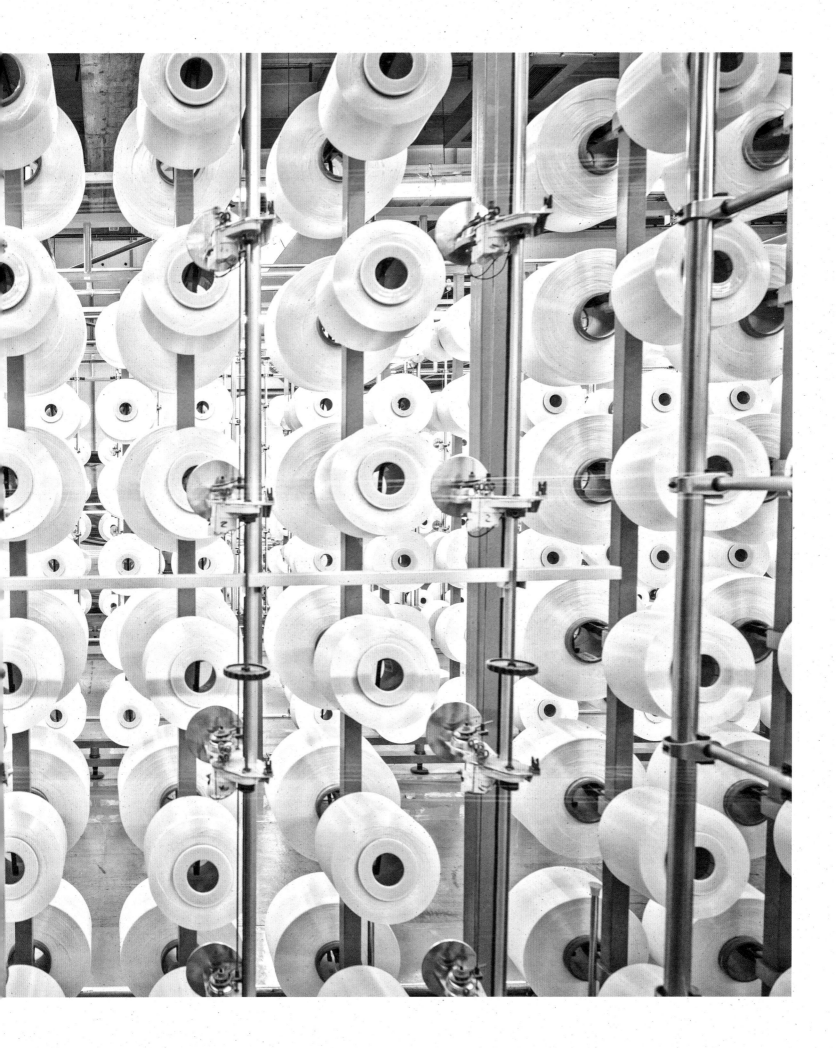

SLOVENIA NYLON RECYCLING

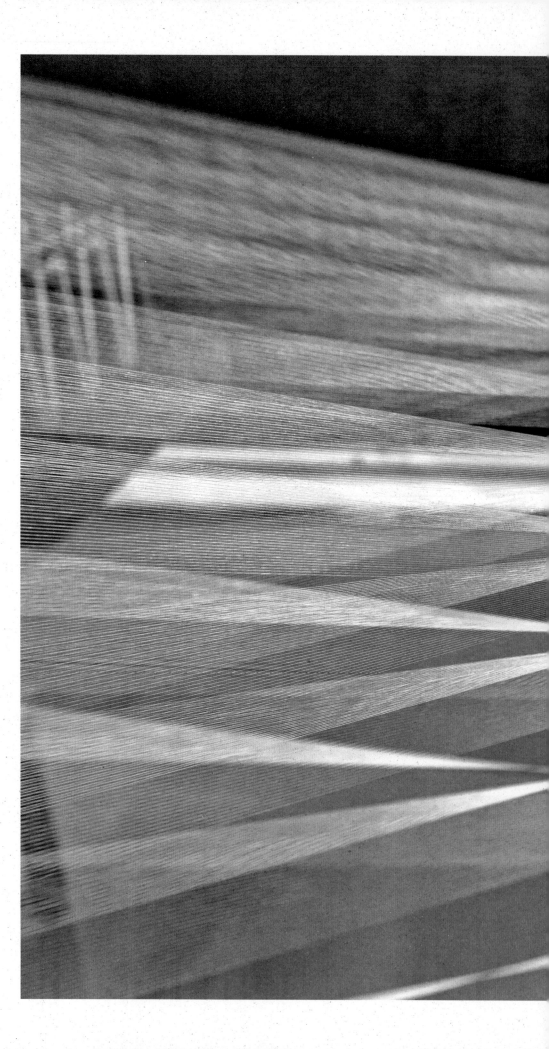

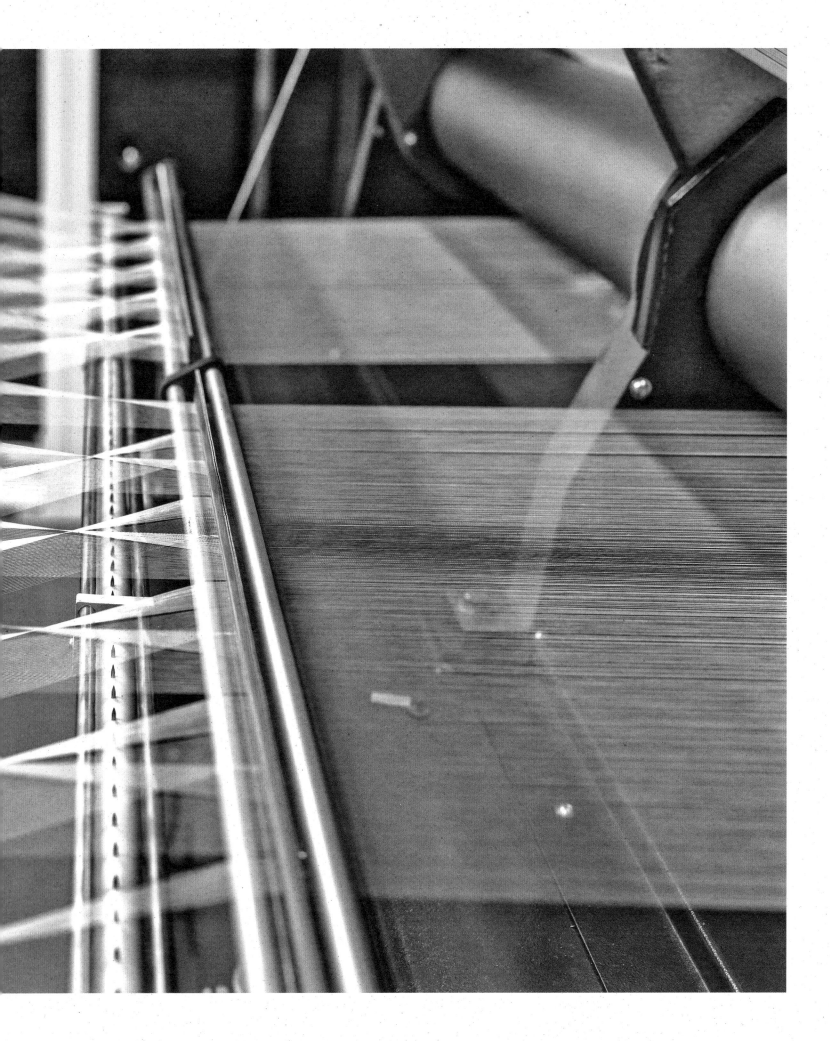

Made from regenerated waste materials, this special type of nylon has a
lower environmental impact in terms of CO_2 emissions as compared to
standard nylon production and can be recycled an infinite number of times.
This technology uses an innovative industrial process to replace
caprolactam (the main component in the production of Nylon 6, which is
derived from petroleum) with alternative raw materials from the recycling of
various types of nylon waste – old carpets, industrial textiles, and especially
fishing nets. To tackle the problem of marine pollution, "The Healthy Seas"
foundation was created in 2013 to spread awareness about prevention
of marine litter and to organise clean-ups with volunteer divers. To date, with
the help of 250 volunteers and 1,250 fishermen and fish farmers, more
than 773 tonnes of fishing nets and other marine litter have been removed
from the sea.

Circular Nylon #5,
Slovenia, 2022

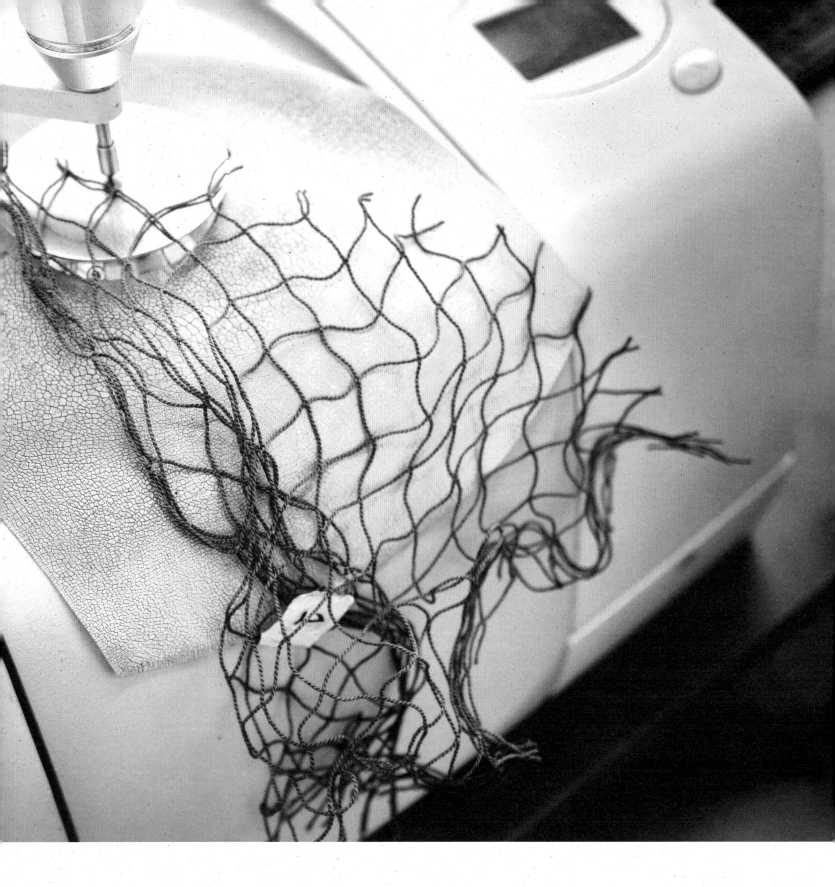

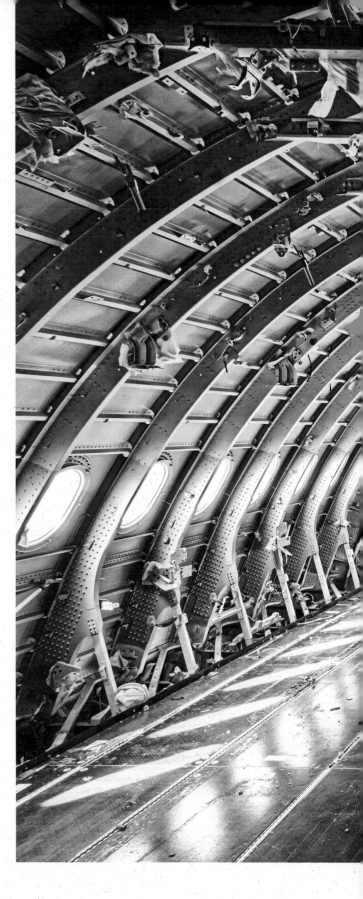

PAMELA (Process for Advanced Management of End of Life of Aircraft) is a project started in 2005 to test environmentally friendly recycling procedures for disused airliners.

Co-funded by the EU LIFE programme, the initiative aimed to demonstrate that aircraft components could be dismantled and recycled safely for reuse in aviation or other sectors. Before PAMELA, there were in fact no standardised procedures for this. The success of the project led in 2009 to the creation of a business dealing with the intelligent dismantling and recycling of decommissioned aircraft. Located near Tarbes airport in south-west France, the facility has the capacity to dismantle up to 30 large aircraft per year. Since 2007, 517 aircraft have been stored and 117 have been recycled, with a 92% reuse rate of the remaining parts. The company aims to dispose of the 6,000 aircraft that will be retired in the next 15 years.

First Class A380 Recycle
Facility #1, France, 2022

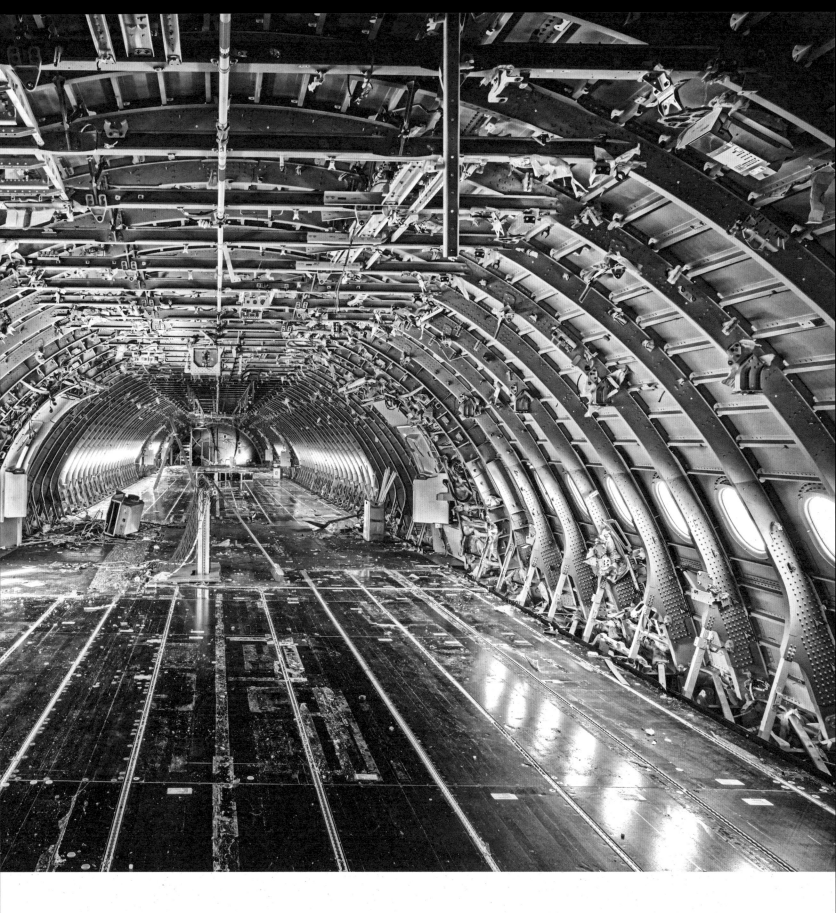

ITALY INSECT FARM

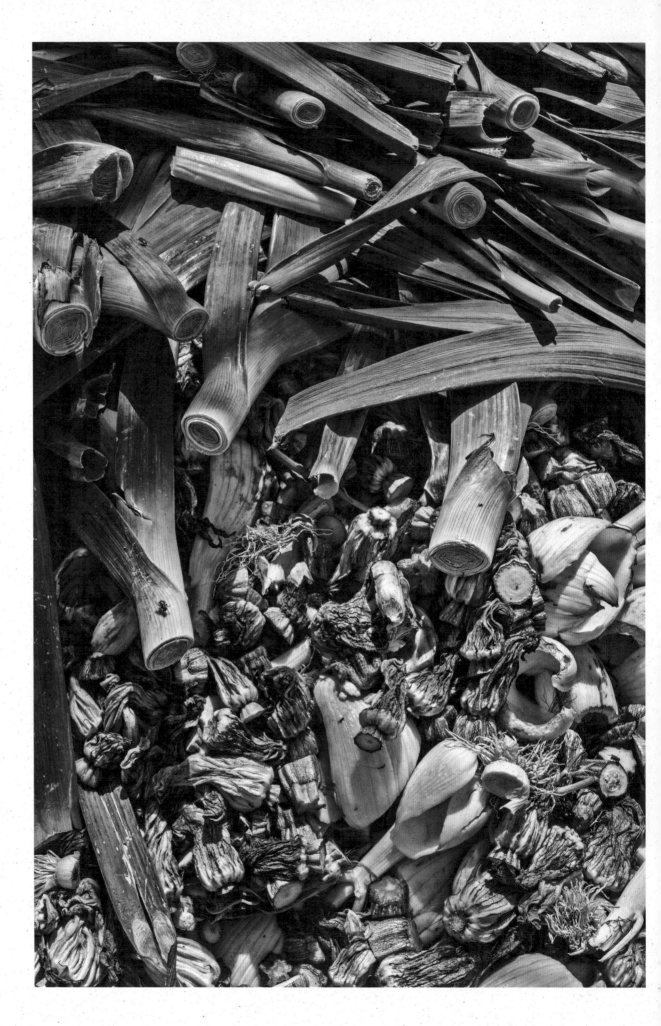

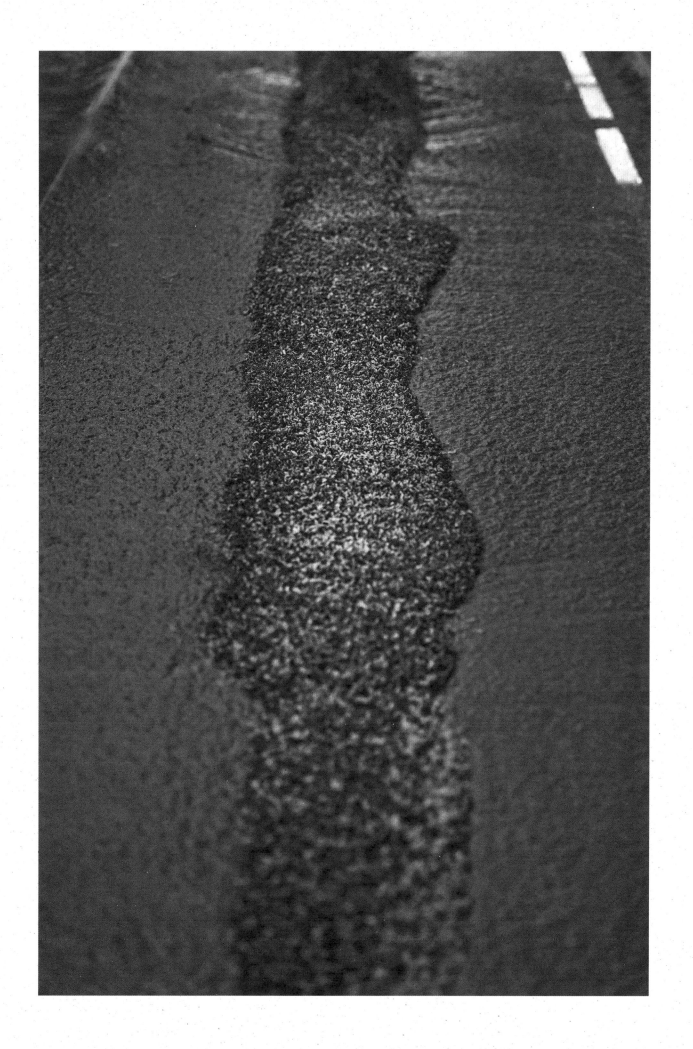

ITALY INSECT FARM

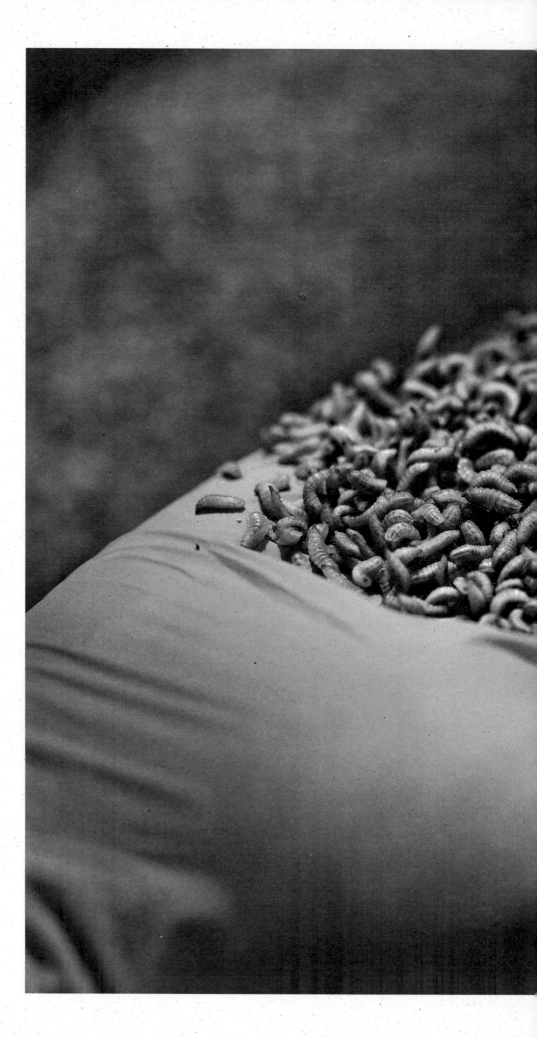

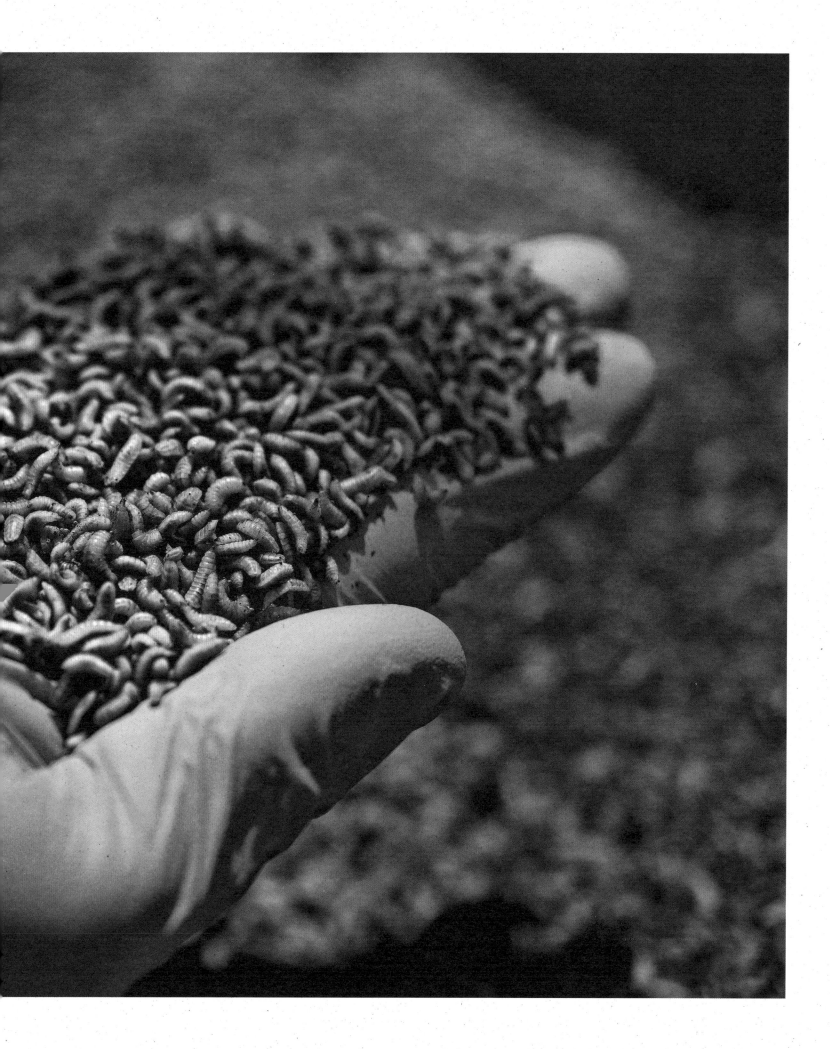

This Turin-based start-up recovers food waste for breeding insects
for the production of protein meals, protein oils, fertilisers and chitin for
the agricultural industry.

Their model is based on the distribution of small insect farms, which are
easier to manage overall and more cost-efficient.

The aim is to create technologies and processes with lesser impact on the
planet than competing models of insect farming.

In particular, they have patented an innovative technology for breeding
Hermetia illucens, the black soldier fly, using a circular process that generates
a positive and measurable environmental impact together with an
economic return for all stakeholders, such as farmers, biogas plant owners,
waste producers, municipalities, feed and chemical industries.

The company aims to achieve several goals of the UN's 2030 Agenda
for Sustainable Development. Using thermal energy from biogas plants and
solar energy, the start-up has planned its activities in a circular economy
perspective based on the insect life cycle; the production cycle greatly
reduces CO_2 emissions compared to other competing industries, and the
company's insect meal replaces fish meal as a main component for
animal feed.

Protein meal is an ingredient for the production of feed for various farm,
aquaculture and domestic animal species. Protein oils are an ingredient for
functional diets that provide a quick source of energy due to high levels of
easily digestible medium-chain fatty acids, especially for younger animals.
Residual digestate from insect feeding is an organic soil conditioner as it
contains many nutrients with a high N-P-K ratio. Chitin is a natural
biopolymer: flexible and hard, it is degradable by specific enzymes.

These are all very useful in the production of surgical sutures, bandages
and even synthetic leather.

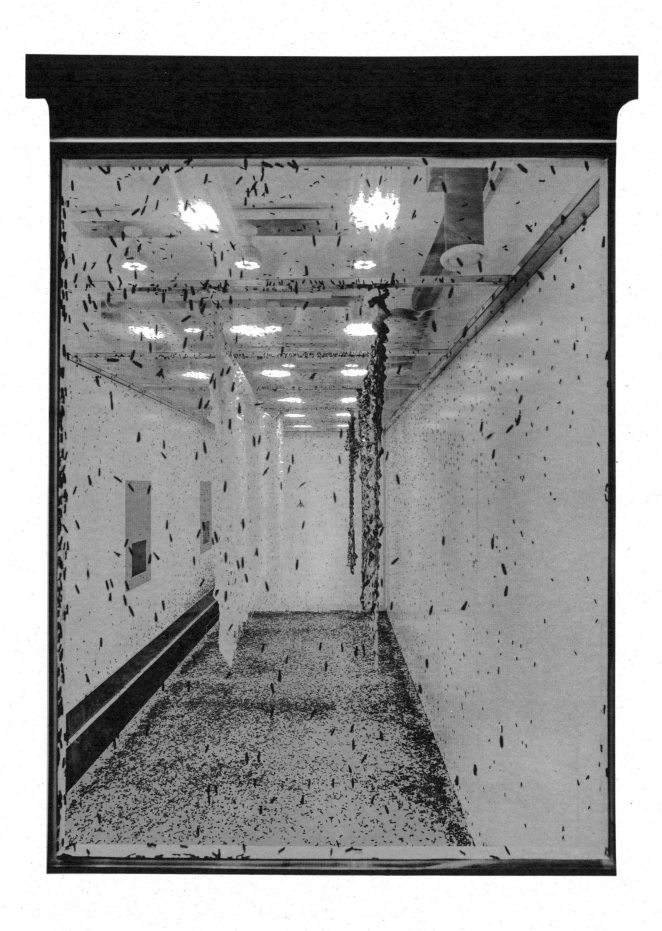

This Austrian company cultivates algae for human consumption. The verticality of its cultivation system ensures a small footprint, but gives the algae a large growth area. The use of a closed system prevents the evaporation of water, which is therefore not wasted but reused within the production cycle.

CO_2 is another necessary element, which means that the system acts as a cleaning machine for other industrial plants that produce carbon dioxide as an unwanted by-product. The CO_2 and air are also used as a substitute for a traditional pump system, ensuring stress-free growing conditions. The system utilises biogenic, non-fossil carbon dioxide.

Another necessary factor for production is sunlight. Vertical bioreactors are designed to be struck by sunlight on all sides, assuring optimal growth of the culture.

Austria's low temperatures provide a strategic climate for the industrial plant. Microalgae have, among other things, the ability to convert carbon dioxide into oxygen, purifying the environment. The algae are utilised 100%, reducing waste to practically zero. In the end, therefore, oxygen is the only real "waste product" created. The production is also GMO-free. In particular, the presence of a very effective strain of algae, called *Chlorella vulgaris*, within the bioreactors means that one tonne of algae can absorb two tonnes of CO_2. Bioreactors constantly measure the algae's growth environment and use algorithms to balance perfectly light, temperature and pH levels in which they will thrive. Furthermore, unlike open-basin systems, they offer better control of contamination, use less water and can expose a large volume of algae culture to light, ensuring higher productivity.

In agriculture, the average yield per hectare is between 4 and 7 tonnes. In contrast, this plant system allows up to 30–70 tonnes of biomass to be harvested annually.

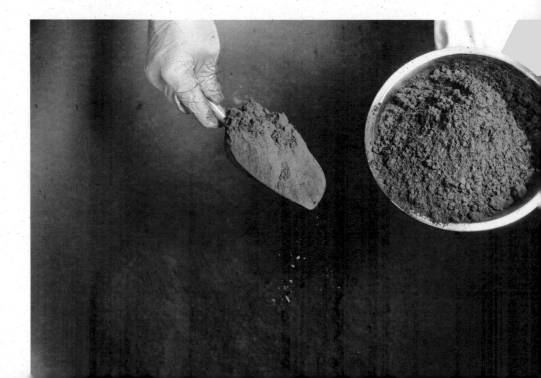

Algae Farm #3, Austria, 2022
Algae Farm #4, Austria, 2022

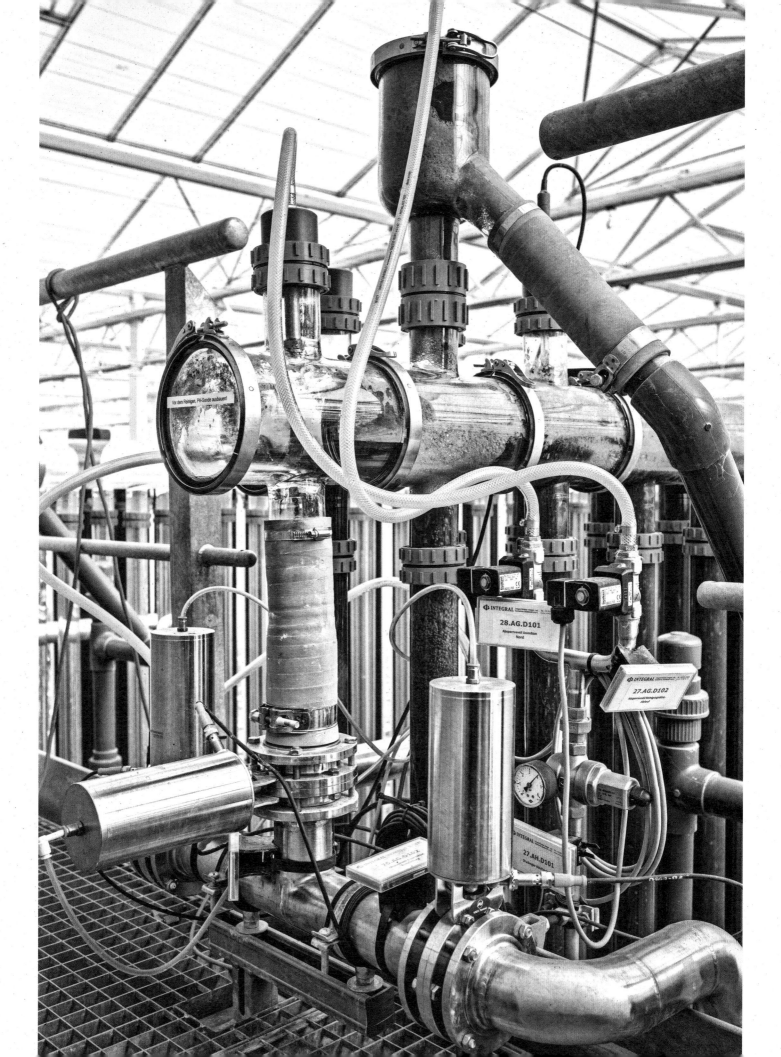

ITALY PAPER PRODUCTION

Active since 1736, in recent decades this paper mill has created several
innovative products based on the principle of the circular economy.
Today, it produces six different types of paper from creative up-cycling,
all FSC-certified™.
The first was Alga Carta, patented in the 1990s and made from the algae that
infested the Venice lagoon. In 2012, it was the turn of Crush, a range of
ecological papers created from agro-industrial waste (citrus fruits, cocoa,
grapes, coconut, cherries, lavender, maize, olives, coffee, kiwi, hazelnuts and
almonds) that reduce the need for cellulose from trees by up to 15%.
2015 saw the launch of Remake, a paper made by upcycling waste from the
leather goods industry, which constitutes 25% of the materials needed
to produce it. Finally, 2019 saw the introduction of the Refit range, which uses
production leftovers from the wool and cotton textile industries that make
up 15% of the raw materials.
In addition to these, they produce Shiro Echo, a 100% recycled paper of the
highest quality, recyclable, biodegradable, FSC-certified™ Recycled and
Tree Free, made entirely from alternative fibres from annual crops. This last
paper is composed of 75% bamboo, a fast-growing grass, and 25% cotton
linters, a pre-consumer waste from the textile industry.
The six papers, part of the "Paper from our Echosystem", are produced with
renewable green energy. They are also carbon-neutral, since the unavoidable
CO_2 emissions are offset by the purchase of carbon credits and by joining
specific environmental projects.
Besides using sustainable resources and residues as raw materials,
the end-of-life of this collection also respects the principles of the circular
economy, being recyclable and also biodegradable.
The paper is produced in plants where the production process is monitored
to reduce water and energy consumption and CO_2 emissions.
The gross production of sustainable paper is about 10,000 tonnes per year.

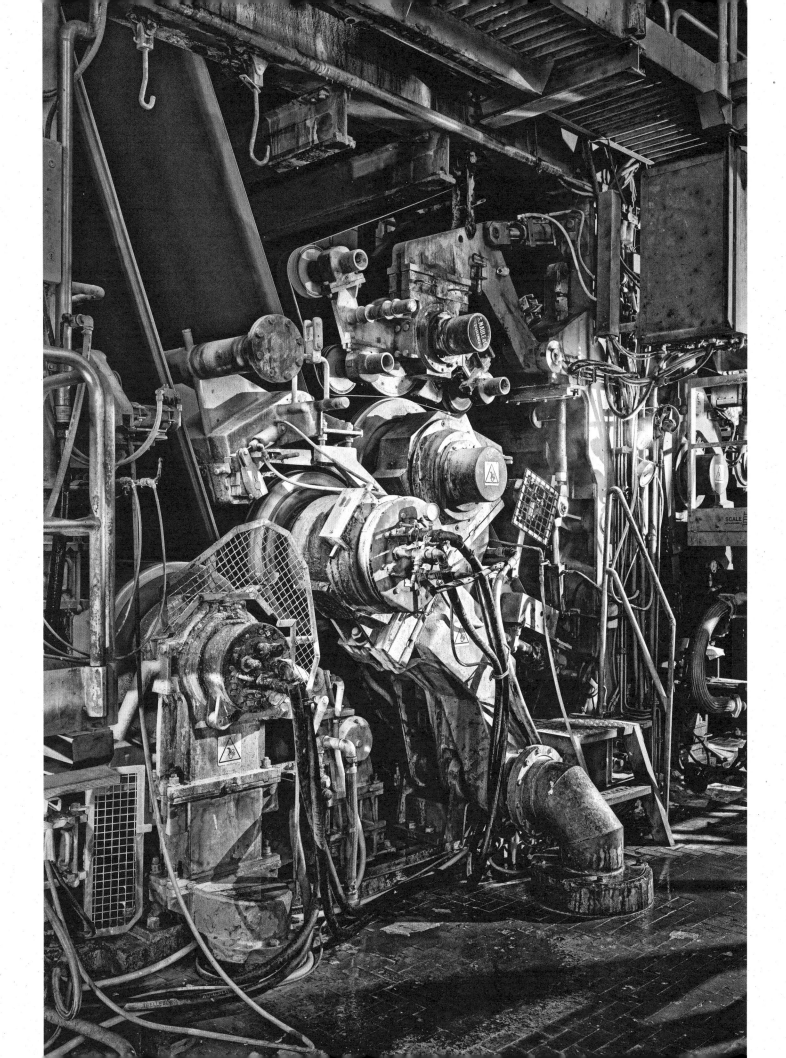

RENEWABLE ENERGY

SWITZERLAND

The Lac des Toules houses the first high altitude floating solar park.
The installation consists of 2,240 square metres of solar panels installed
on 36 floats, except for one.
These floats are made of polyethylene while the structure supporting the
solar panels is in aluminium. The installation presently covers 2% of the
lake's surface and is being used to test the technical and financial feasibility
of a larger floating solar park, which could cover as much as 35% of the
lake's surface.
There is no impact on marine fauna because it is an artificial lake formed by
a dam and there are only a few fish, released for recreational fishing.
However, the project presents some challenges: 120 km/h winds, -30 °C
winters, 60 cm of ice. The solar panels are double-sided and transparent,
so when light passes through them they capture reflections from both
water and snow.
Connected to a power plant at the foot of the dam, the plant will produce
800,000 kilowatt-hours (kWh) per year, equivalent to the annual
consumption of about 220 households. In the future, if expanded, the
floating solar power plant will produce more than 22 million kWh per year,
equivalent to the annual consumption of more than 6,000 households.

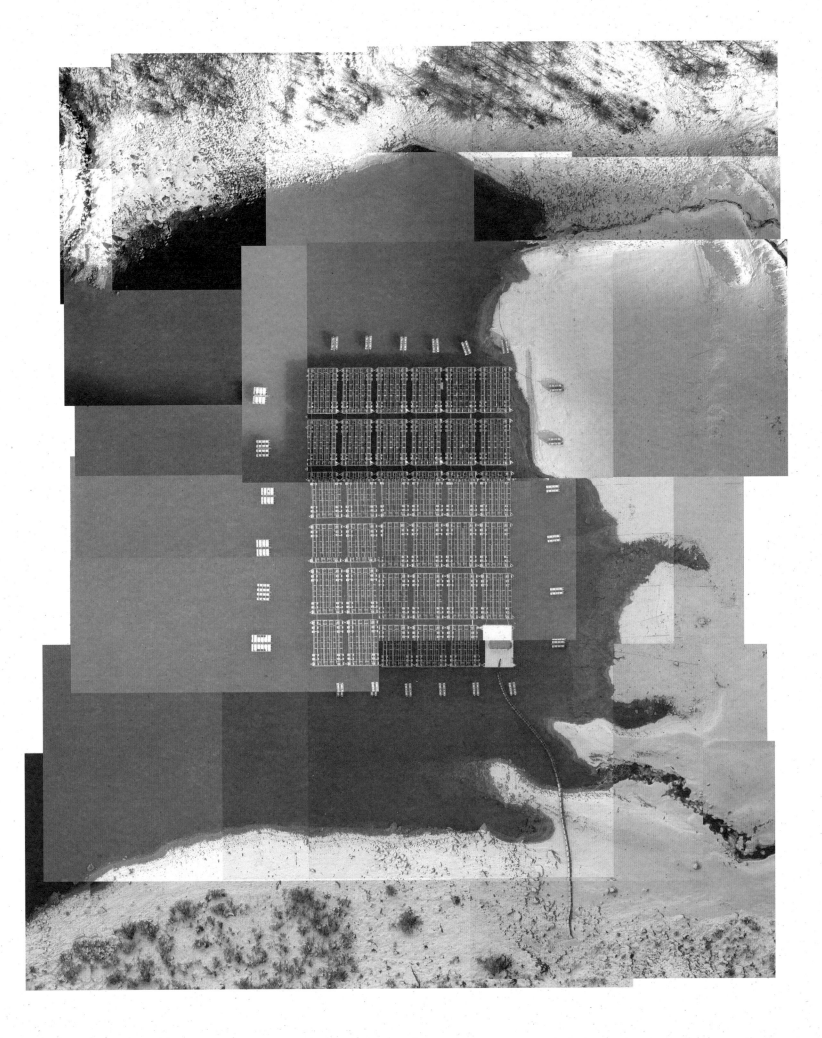

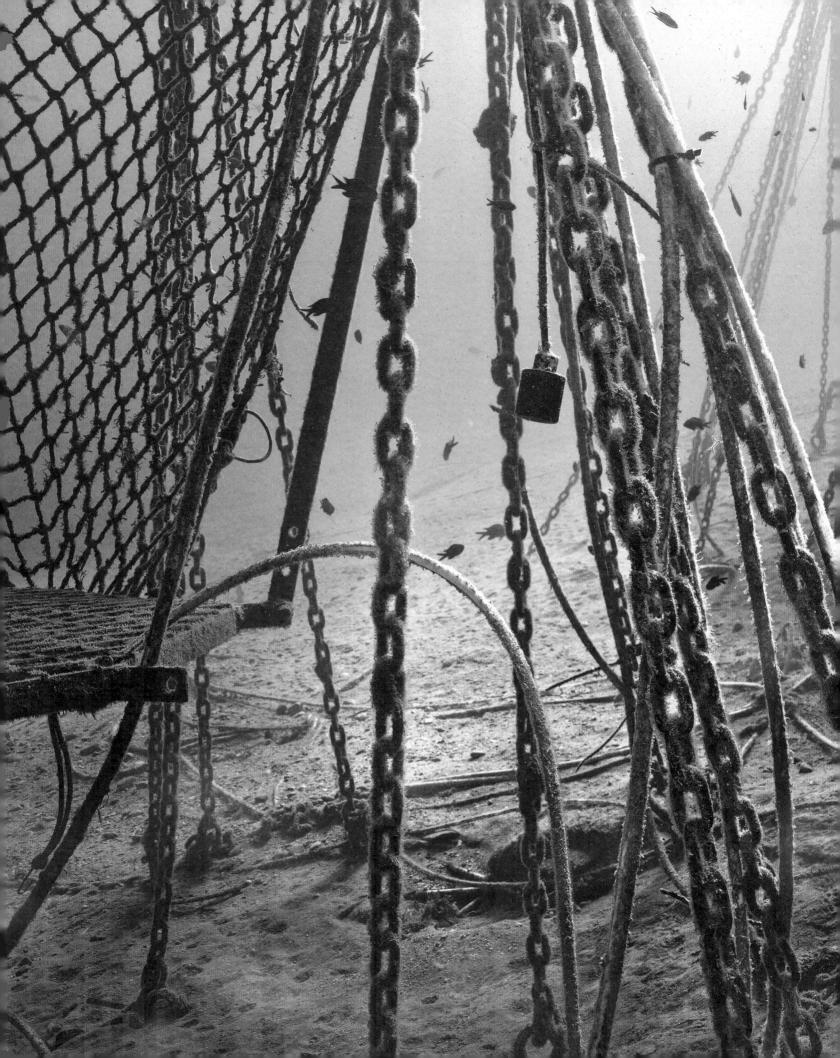

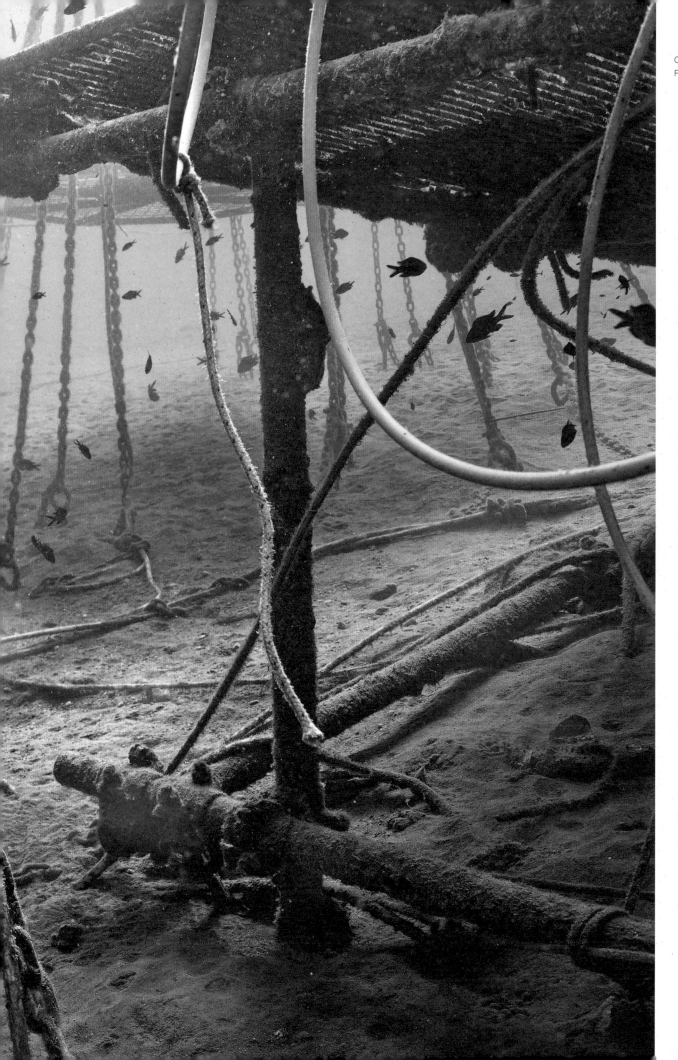

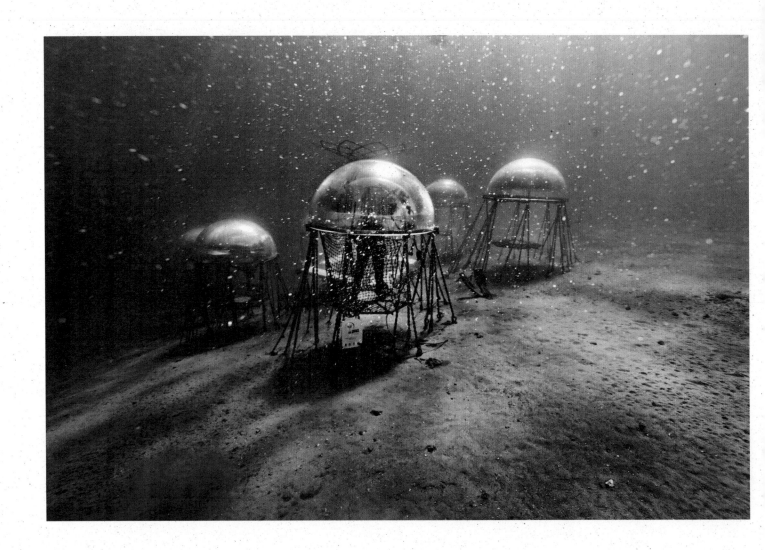

Biosphere Underwater
Farming #2, Italy, 2021

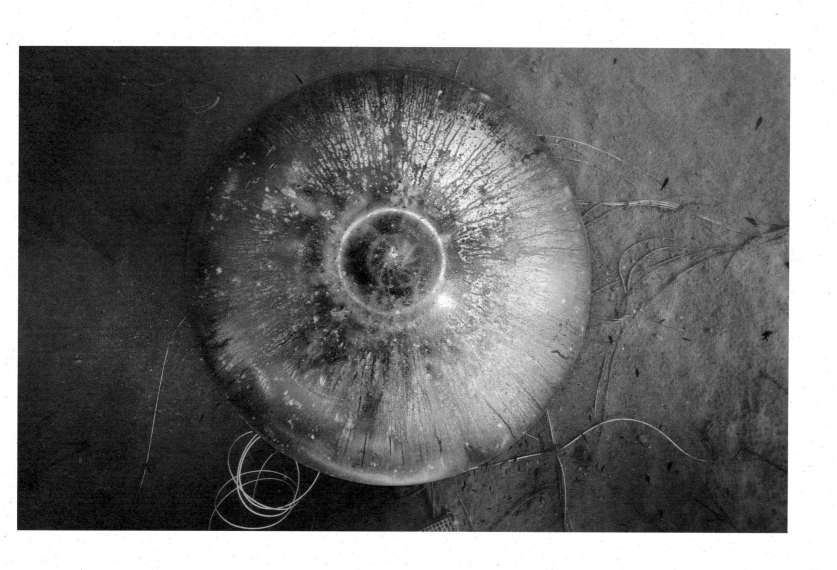

Biosphere Underwater
Farming #7, Italy, 2021

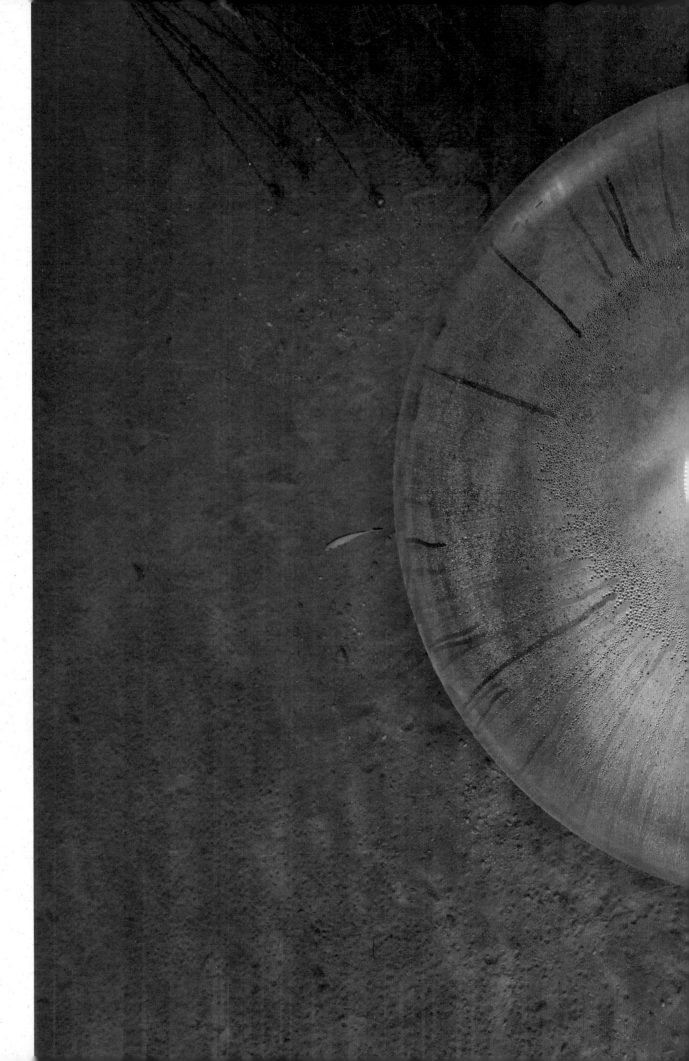

ITALY UNDERWATER AGRICULTURE

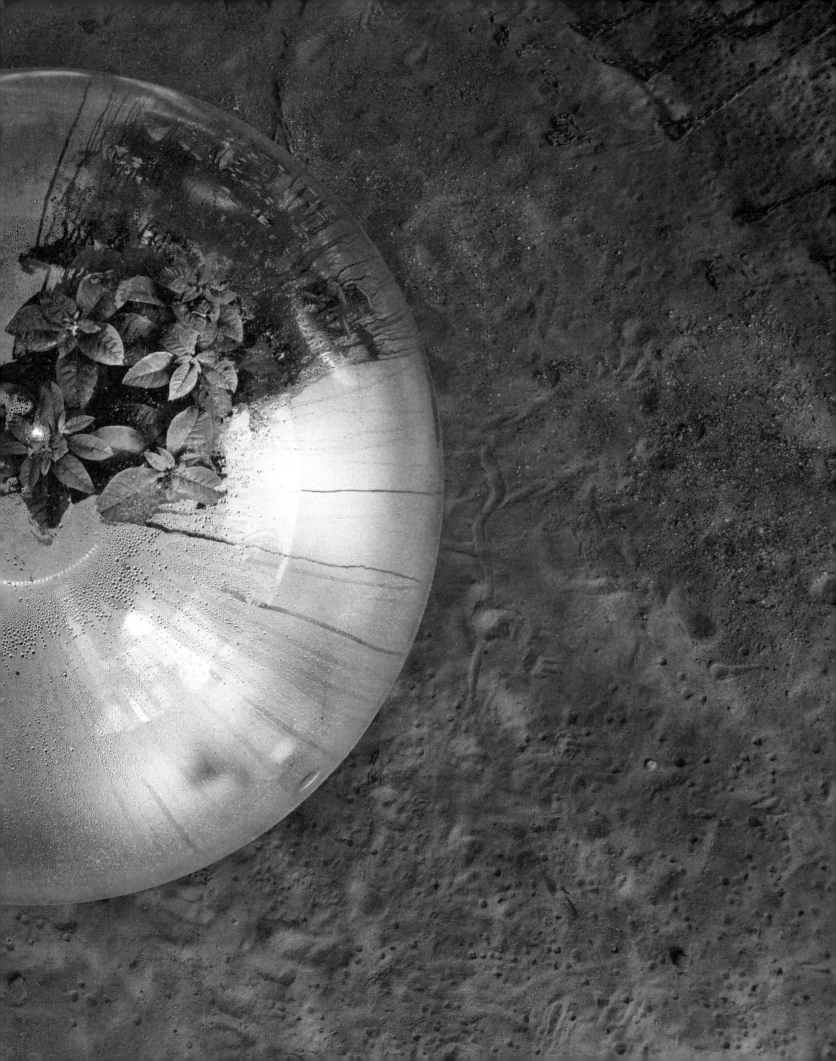

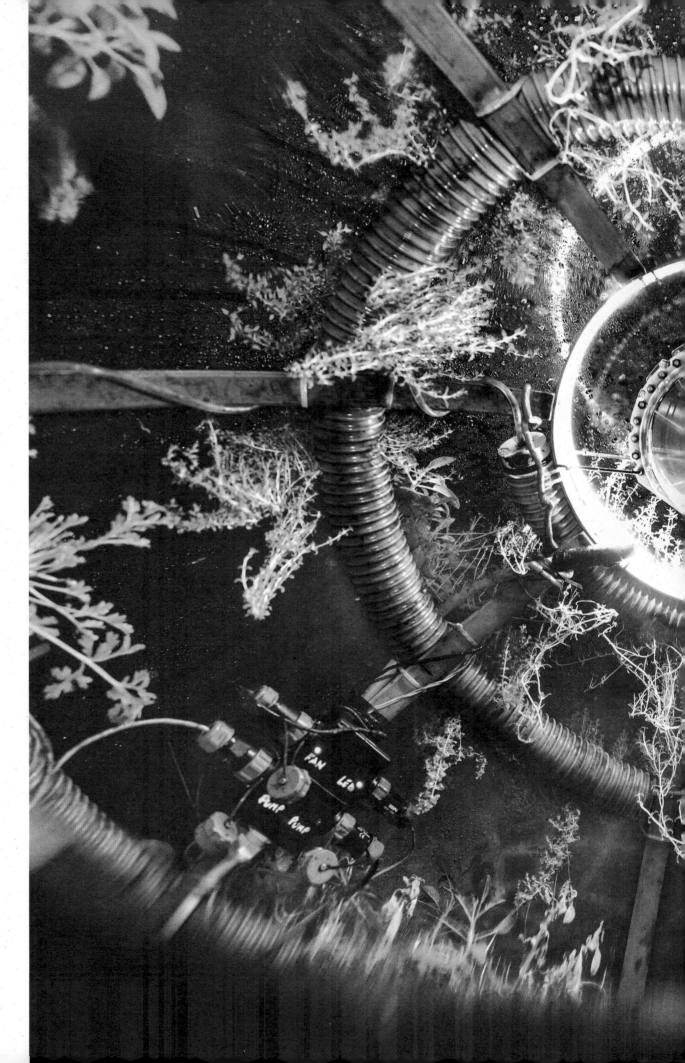

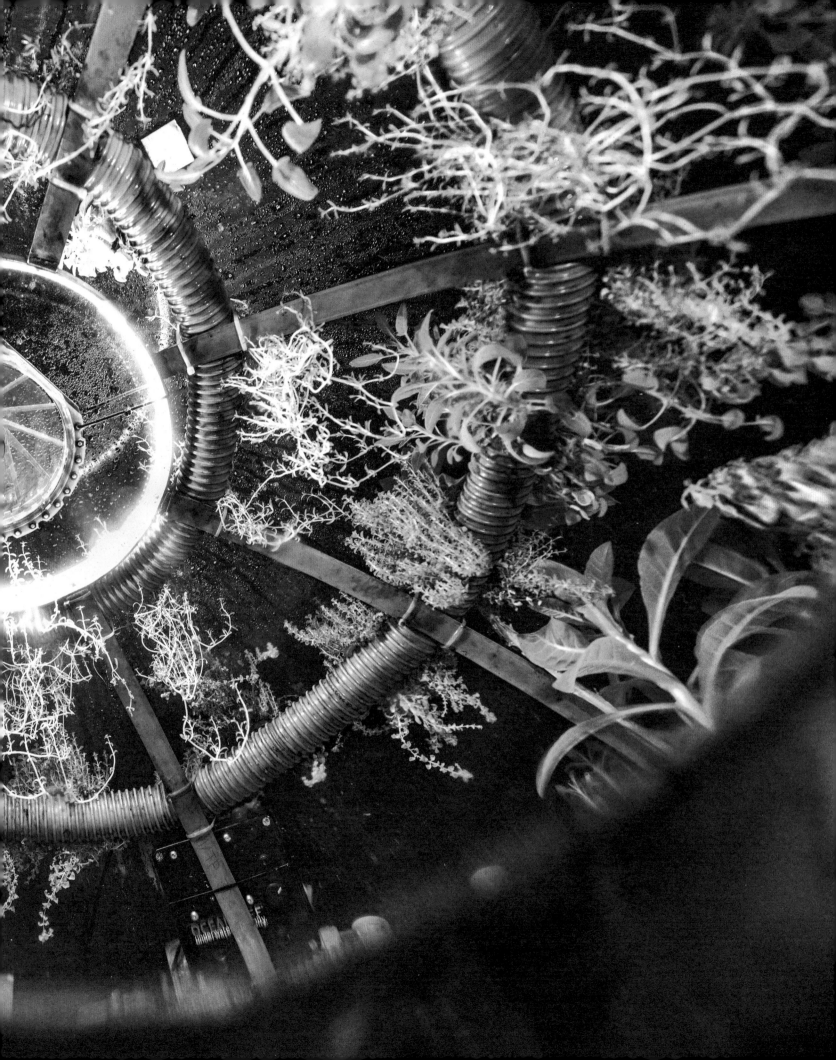

This is the world's first experiment in underwater farming, located in Noli, Liguria. The project started in 2012 to recreate the ideal conditions for growing basil, which is essential for the preparation of pesto. Like most plants, basil needs a sunny environment, moist soil and a constant temperature – conditions that do not exist in some areas of the planet and are difficult to maintain even in historically suitable locations.
This is due to climate change, which has led to a reduction in agricultural productivity over time.
The underwater farm system requires external water only in the start-up phase, later becoming autonomous and self-sustaining: due to the difference in temperature between the air inside the biosphere and the seawater around the structure, the water at the bottom of the biosphere evaporates and condenses easily on the inner surfaces.
Sunlight enters the biospheres through the seawater and the polymer film that forms the dome. Studies are currently under way on how much these two filters might influence production and which plant species are suitable to be cultivated in this configuration.
Agriculture accounts for 70% of the world's freshwater use: water management is required in most regions of the world where rainfall is insufficient or variable. In a nutshell, agriculture is withdrawing water from aquifers and underground sources at an unsustainable rate.
The underwater farming system could also obviate the problem of pesticides: the closed ecosystem created within the biosphere is well protected from attack by pests. Not using pesticides means having an ecological environment in close contact with seawater, thus avoiding any disturbance of the marine ecosystem.
Underwater agriculture aims to create a system that utilises the natural resources already available in nature. It intends to combine respect for the environment and technology, presenting itself as a viable, self-sufficient and sustainable alternative to standard agriculture.

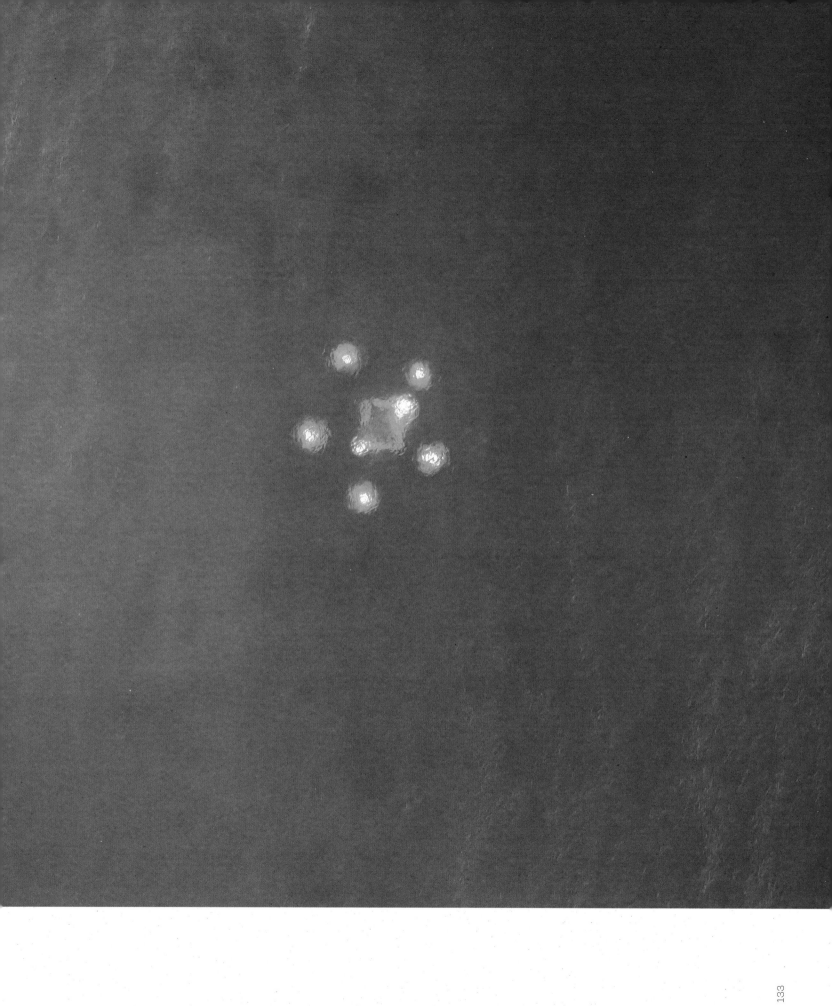

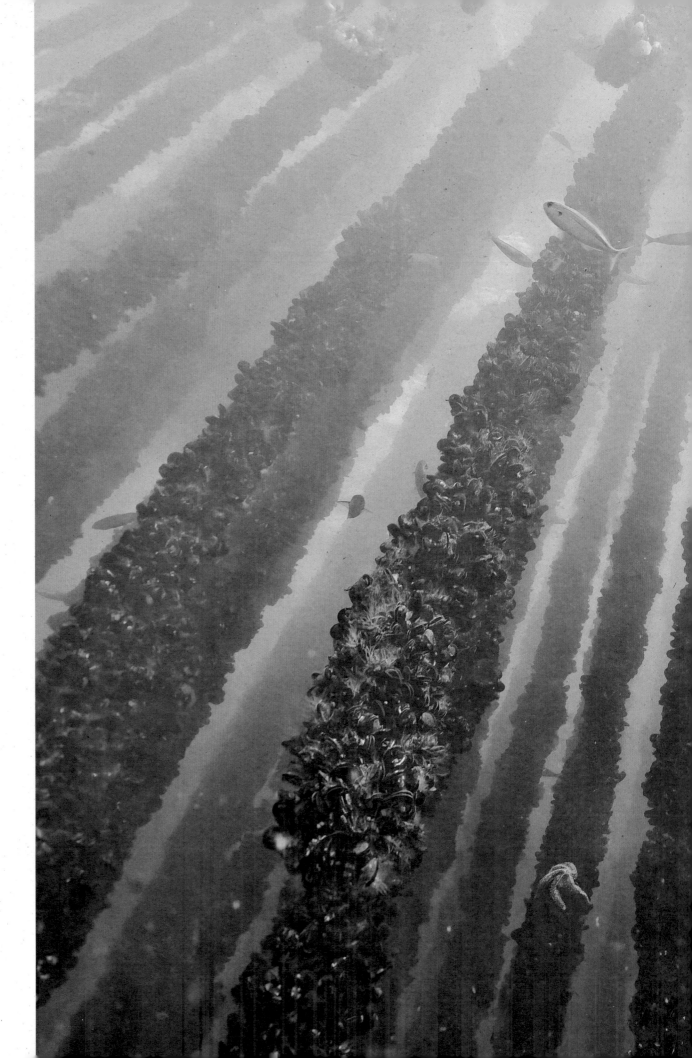

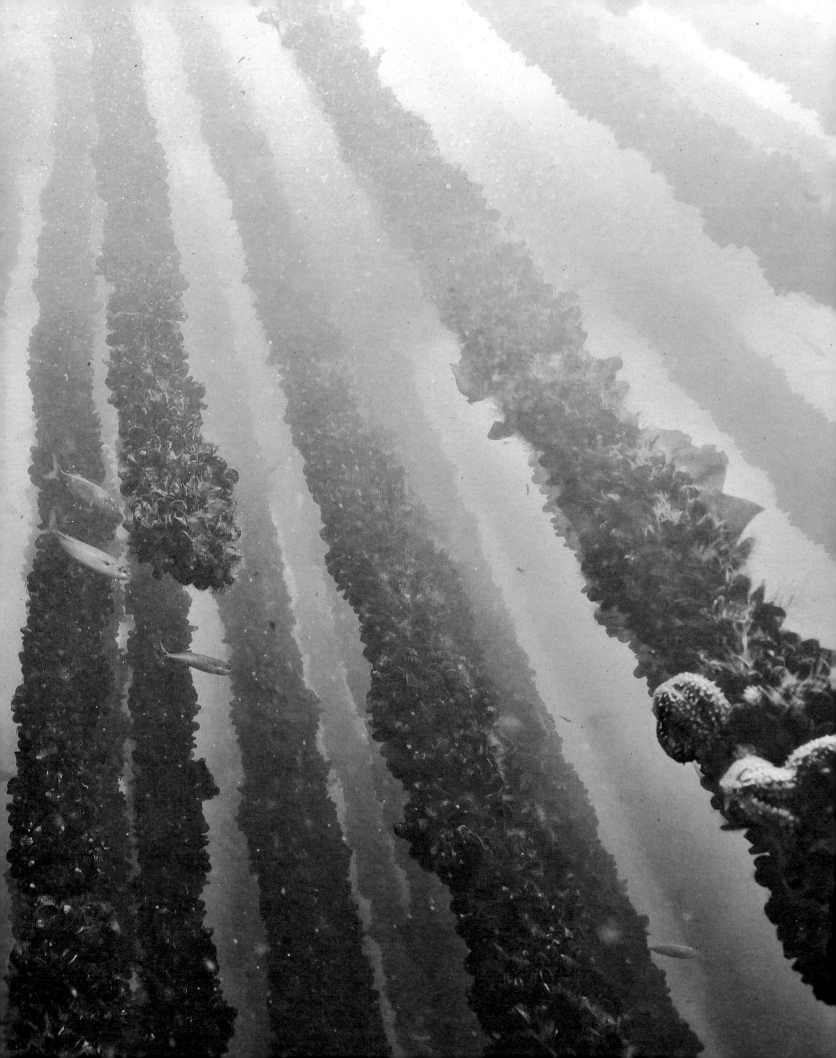

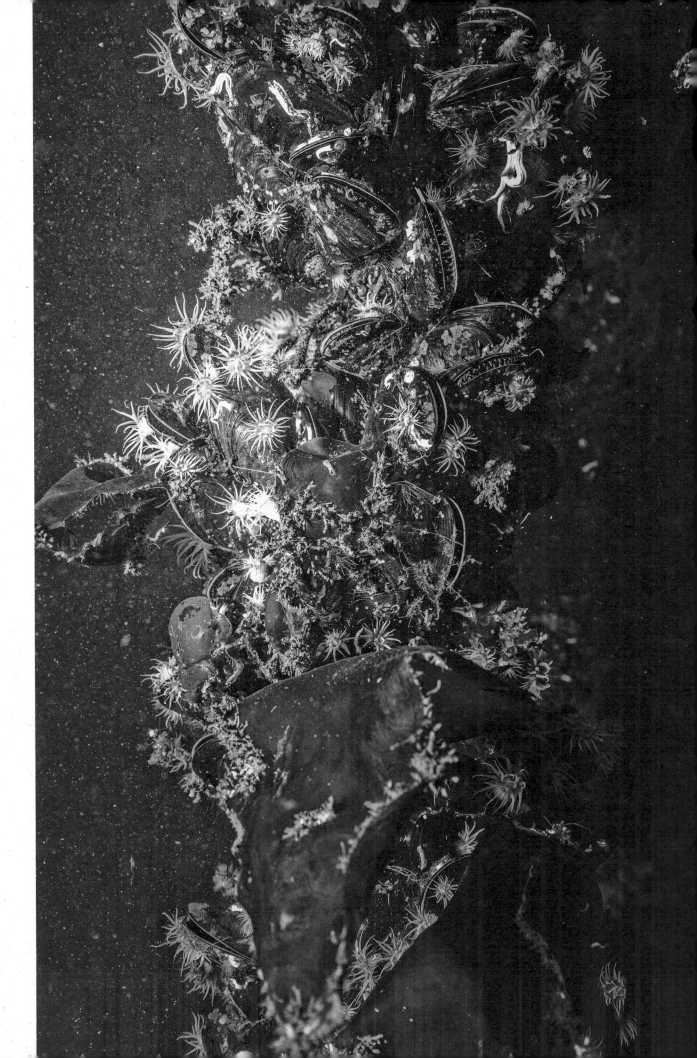

INTEGRATED FOOD PRODUCTION

SPAIN

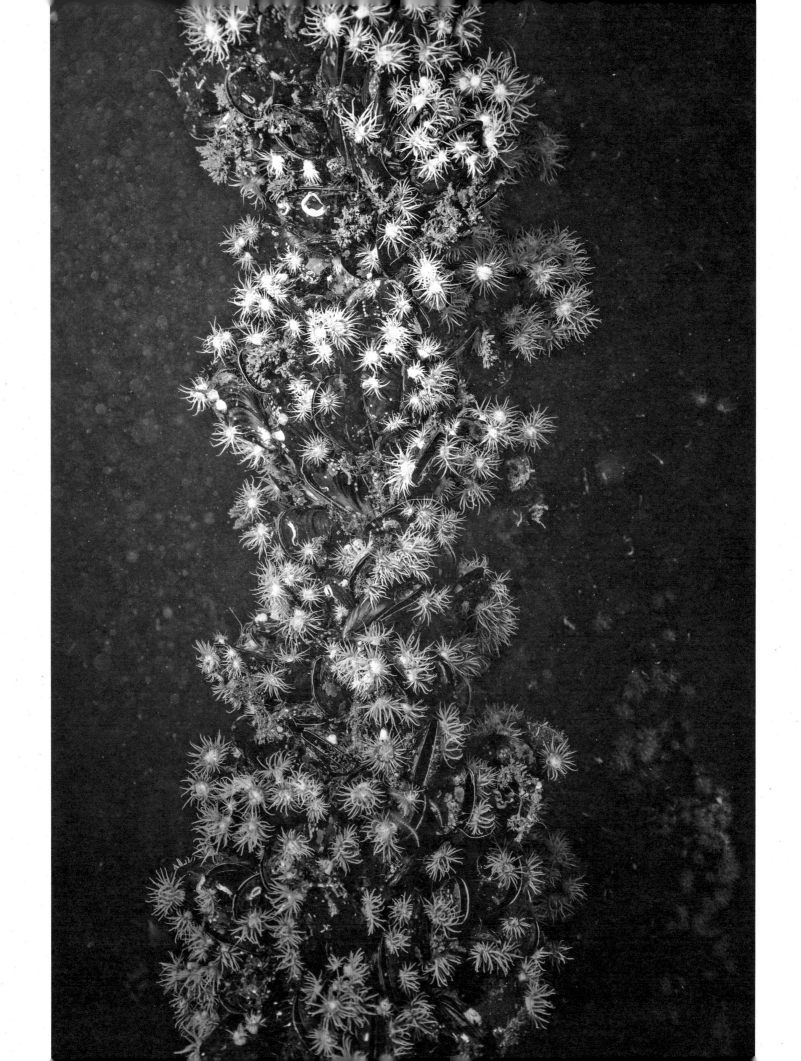

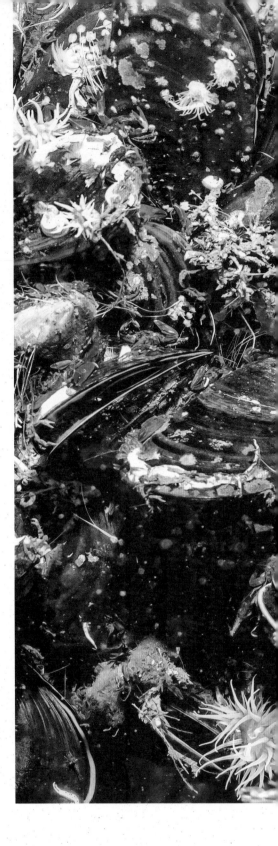

The Galician coast abounds in high-quality seafood due to the great quantity of nutrients, oxygen and plankton in a unique coastal upwelling system. One of the characteristics of the *rías* is the profusion of farms on rafts or *bateas*, floating wooden structures with suspended ropes on which mussels grow (suspended mussel farming). The mussel farms in Galicia represent the largest mussel (*Mytilus galloprovincialis*) production area in Europe. They also increase biodiversity in the water column, providing shelter for fauna and anchorage for macroalgae. These molluscs sit at the lowest level of the food chain, as filter feeders, sustaining themselves with the microscopic organic matter in the waters of their surroundings. With a higher protein content than many meats and vegetable crops and high levels of omega-3 fatty acids and essential micronutrients such as iron, zinc and magnesium, shellfish have the potential to combat many global food problems, including child malnutrition. Bivalves can be both wild-harvested and farmed in the open sea and coastal areas, with minimal environmental impact compared to animal protein. Mussel farming has developed in the European Union and more strongly in the last thirty years, although it had already started in Galicia more than 50 years ago.

There are currently around 3,300 rafts dedicated to mussel cultivation in Galicia, producing 270,000 tonnes per year, or 94% of Spanish production and 50% of European production.

Each raft can have a maximum of 500 ropes hanging from it, which, by exploiting the natural characteristic of molluscs to attach themselves firmly, create immense colonies.

The filtration rate is high: a 5-centimetre mussel can filter 1.75 litres per hour. The mussels on a rope are able to filter no less than 90,000 litres of water per day, with an entire raft capable of filtering about 70 million litres in the same period of time.

Nature Power Mussels
Biodiversity #1, Spain, 2022

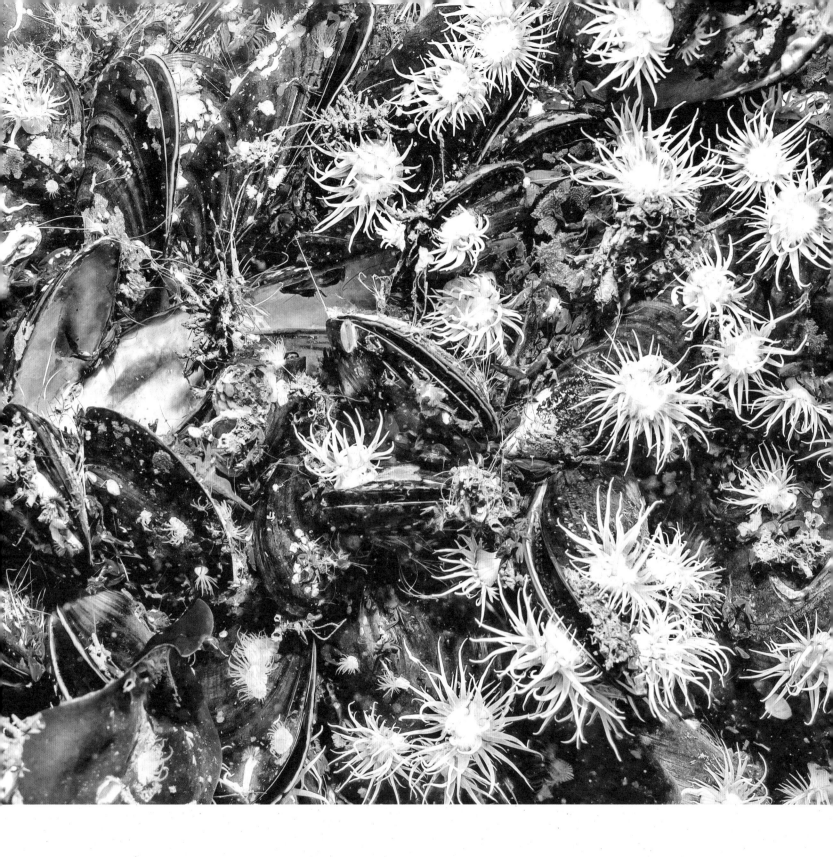

Photosynthesis is a vital biological process that occurs in plants, algae and some bacteria, enabling them to convert light energy into chemical energy in the form of glucose. This process plays a crucial role in sustaining life on earth, producing oxygen and providing a source of organic compounds for various organisms.

At the heart of photosynthesis is chlorophyll, a pigment found in the chloroplasts of plant cells. When the light energy from the sun reaches the chlorophyll molecules, it excites the electrons inside them. These excited electrons initiate a complex series of chemical reactions, known as light-dependent reactions.

Glucose serves as an energy source for the plant and is also used to produce other important organic compounds, such as starch and cellulose.

Elodea is an aquatic plant that is commonly used in biology experiments to study photosynthesis. When placed in water, it continues to perform photosynthesis, using the carbon dioxide dissolved in the water.

Oxygen is a by-product of photosynthesis. It accumulates within plant cells, particularly in specialised structures called oxygen evolution complexes, which are involved in light-dependent reactions. Oxygen accumulates in these structures and forms small bubbles.

When these oxygen-filled bubbles become large enough, they detach from the Elodea plant and rise to the water surface, where they can be observed as visible bubbles. The process of oxygen production and bubble formation is an indirect indicator of the photosynthetic activity of the Elodea plant. This fascinating phenomenon is a visual demonstration of the vital role that photosynthesis plays in sustaining life on earth.

Nature Power
Photosynthesis
Microscope #2,
Italy, 2023

Following pages
Nature Power
Photosynthesis
Microscope #1,
Italy, 2023

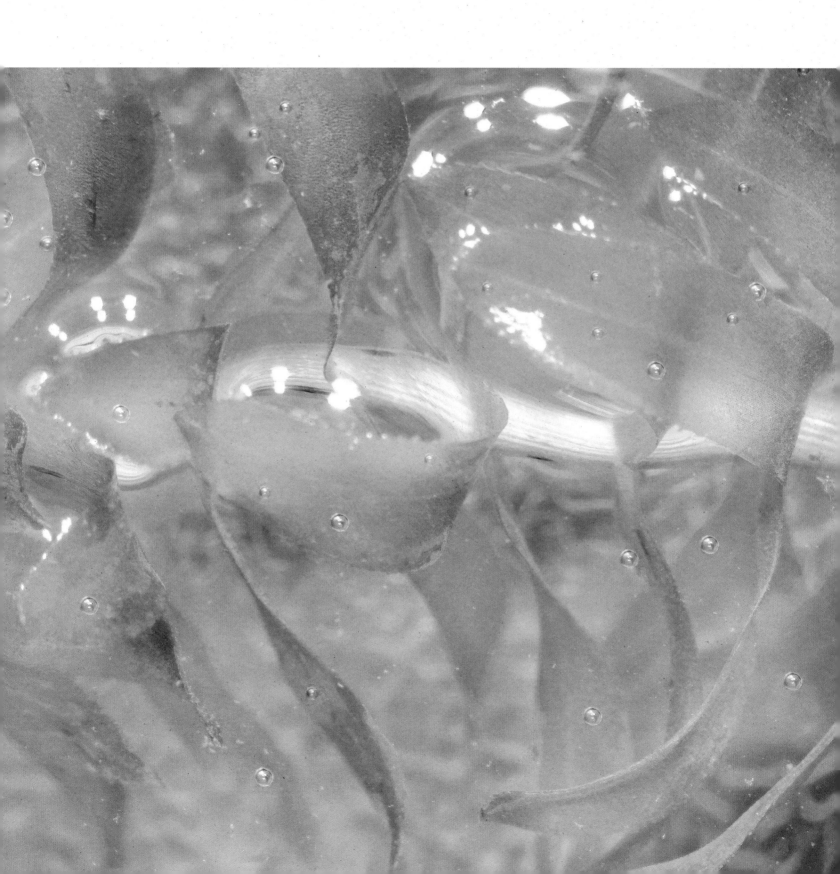

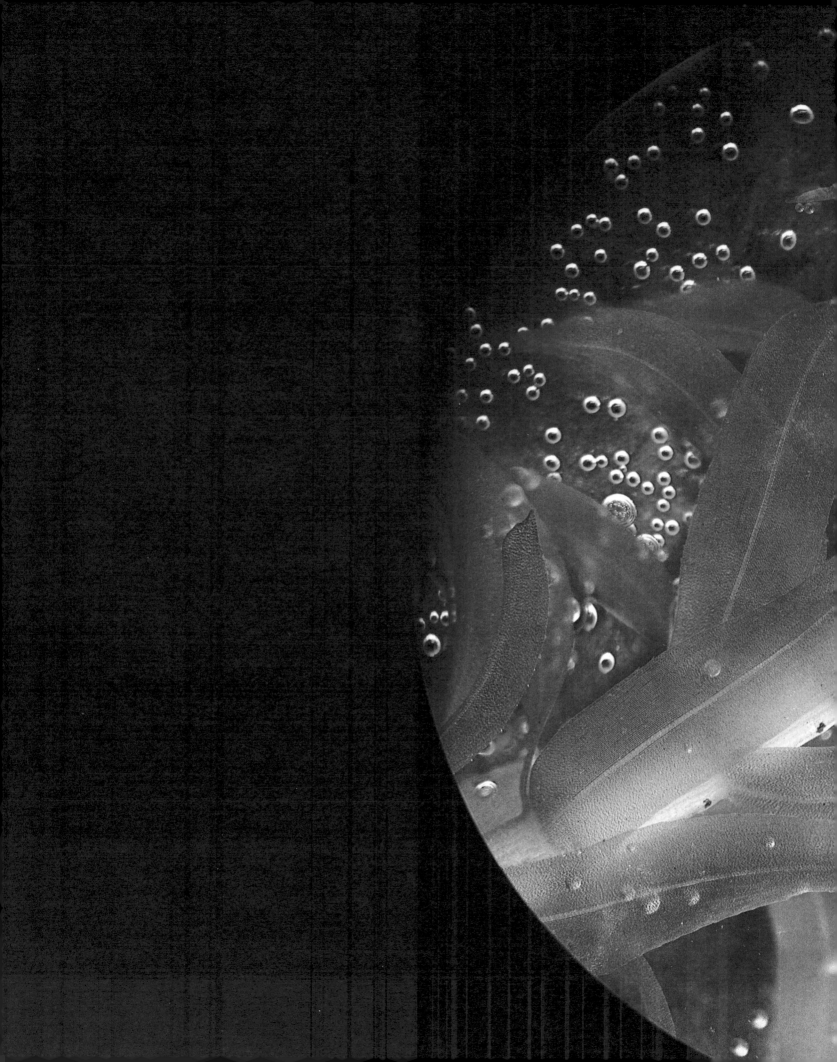

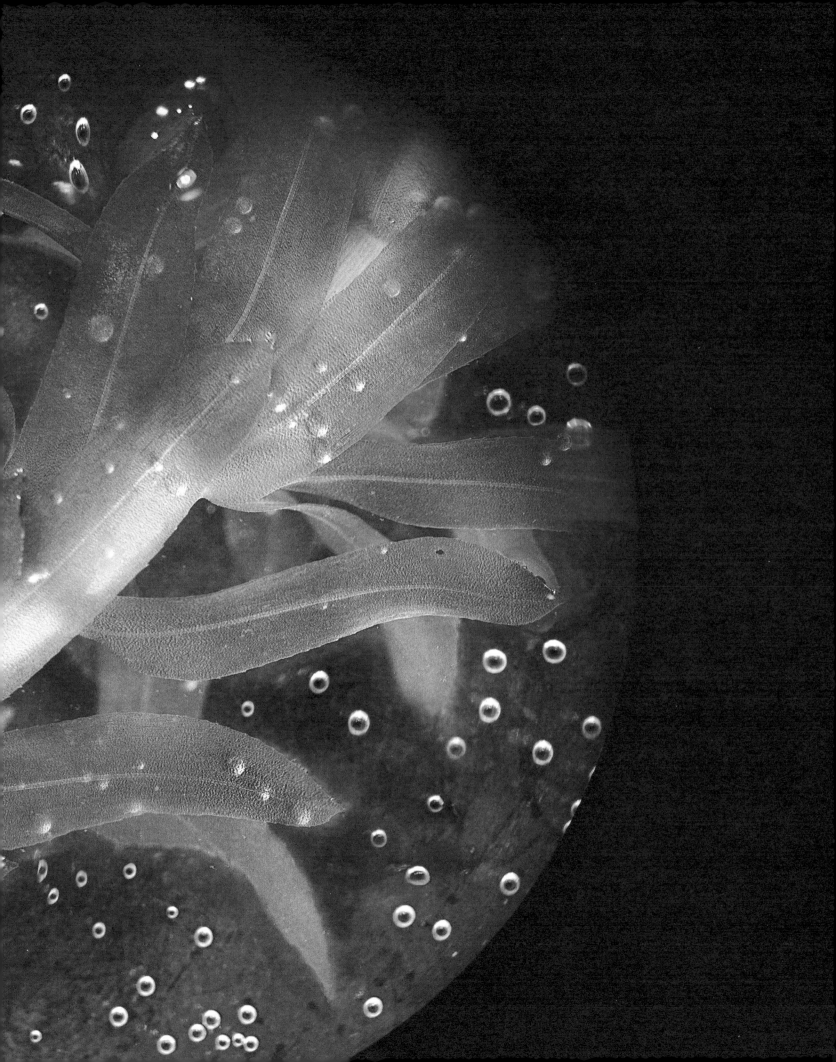

Federica Fragapane is an independent information designer.
Over the years, she has realised projects for Google, the United Nations, the Publications Office of the European Union, BBC Science Focus, and she regularly collaborates with *La Lettura* magazine.
She has been a guest lecturer at the Harvard University Design Labs and at the Royal College of Art in London, among others.
In June 2023, three of her projects were acquired by MoMA New York and became part of the permanent collection.

Luca Locatelli is a photographer and filmmaker who focuses on the relationships between people, science, technology and the environment. His projects are realised in collaboration with journalists, environmentalists and scientists to contextualise his research further. Deeply rooted in documentary production, his research has for more than a decade focused on exploring plausible solutions to the climate crisis of the 21st century. The aim of his work is to contribute to an open discussion about our future on the planet. Since 2004 he has been a founding member of an NGO that is helping to protect 600,000 hectares of rainforest in the Amazon. Locatelli is a *National Geographic* photographer and a regular contributor to international press, including *The New York Times*, *Time* and *The New Yorker*. His work has been exhibited and presented in various venues including the Solomon R. Guggenheim Museum in New York, the Shanghai Center of Photography, Somerset House in London, Les Rencontres d'Arles and Visa pour l'Image. His work has been recognised and awarded various prizes, including: Aftermath Grant Winner, 2014; Nannes Prize, 2017; American Photography Winners, 2018; World Press Photo, 2018 and 2020; World Photography Organization, 2018, 2020, 2021 and 2022; Leica Oskar Barnack Award, 2020.

Elisa Medde works with photography and visual culture as a curator, editor, essayist and lecturer.
As an expert on photographic image, she has been a nominator and jury member for several national and international awards, including the Mack First Book Award, Luma Rencontres Dummy Book Award, Cortona on the Move, LensCulture Award, Prix Élysée, Leica Oskar Barnack Award and MAST Foundation for Photography Grant. She contributes to various national and international press, including *Artribune*, *Flash Art Italia*, *Time*, *Foam*, *Something We Africans Got*, *Vogue Italia* and *L'Uomo Vogue*, *YET*, *C4 Journal*.
From 2012 to 2023, she was editor-in-chief of *Foam – International Photography Magazine*, which was twice (2017, 2019) named "Best Photography Magazine of the Year" by the Lucie Foundation in New York.
Since 2021 she has been a member of the board of the Salwa Foundation, Amsterdam.